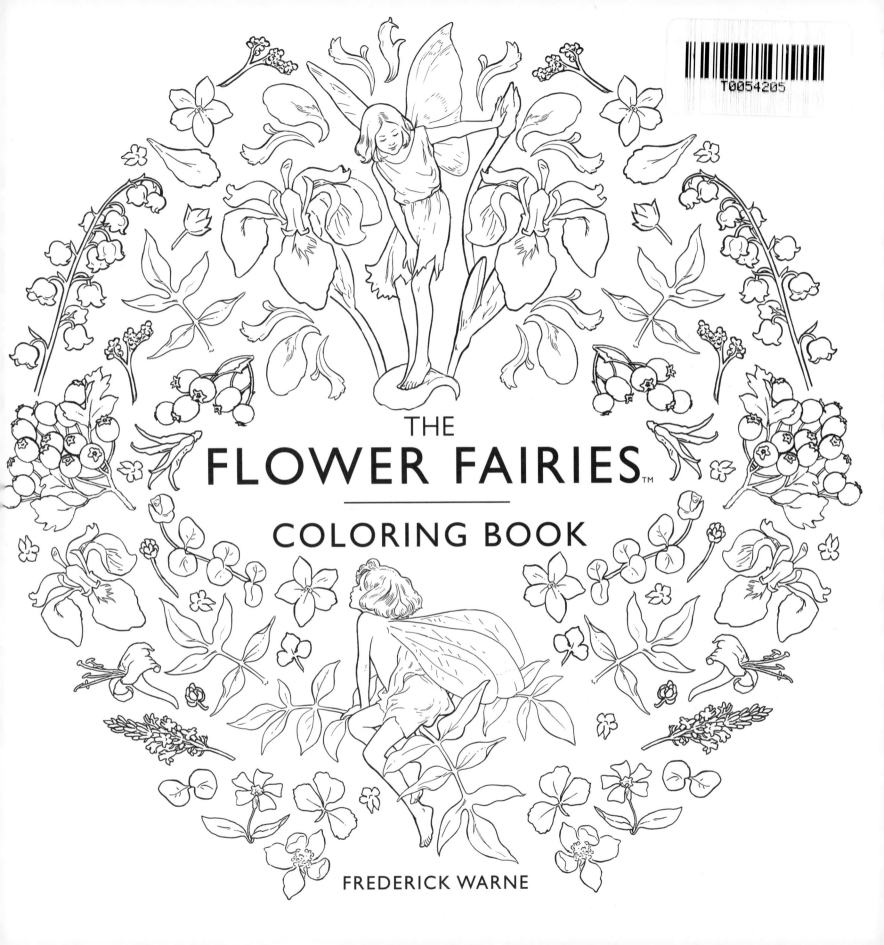

THE
FLOWER FAIRIES™
COLORING BOOK

FREDERICK WARNE

FREDERICK WARNE
Penguin Young Readers Group
An Imprint of Penguin Random House LLC

Penguin supports copyright. Copyright fuels creativity, encourages diverse voices,
promotes free speech, and creates a vibrant culture. Thank you for buying an
authorized edition of this book and for complying with copyright laws by
not reproducing, scanning, or distributing any part of it in any form
without permission. You are supporting writers and allowing Penguin to
continue to publish books for every reader.

The publisher does not have any control over and does not assume
any responsibility for author or third-party websites or their content.

First published in the United Kingdom in 2016 by Frederick Warne.
First published in the United States of America in 2017 by Frederick Warne, an imprint of
Penguin Random House LLC, 1745 Broadway, New York, New York 10019, USA

Manufactured in China

ISBN 978–0–241–28179–6

10 9 8 7 6 5 4 3 2

THIS BOOK BELONGS TO

. .

THINGS TO FIND . . .

A MAGIC WAND

A FAIRY'S SHOE

A JINGLING BELL

SWEET STRAWBERRIES

A BEAUTIFUL BUTTERFLY

A SHINING MOON

A FAIRY WITH A LANTERN

A ROYAL FAIRY'S CROWN

A FRIENDLY SNAIL

A BUZZING DRAGONFLY

A SHOOTING STAR

A FURRY MOUSE

THROUGH WHIMSICAL WOODLANDS AND WONDROUS WILLOWS,
FOLLOW THE FAINT SOUND OF TINY BEATING WINGS AND VENTURE
DEEP INTO THE ENCHANTED WORLD OF THE *FLOWER FAIRIES* . . .

Inside this book you'll find exquisite illustrations of Cicely Mary Barker's
timeless ethereal characters from spring, summer, autumn, and winter. Fluttering
across these pages, the Flower Fairies are waiting for you to bring them to life.

Add color to every illustration, breathe magic into every
page, and explore each picture to find the items listed here.
Be sure to also look for the fairies hiding in every pattern!

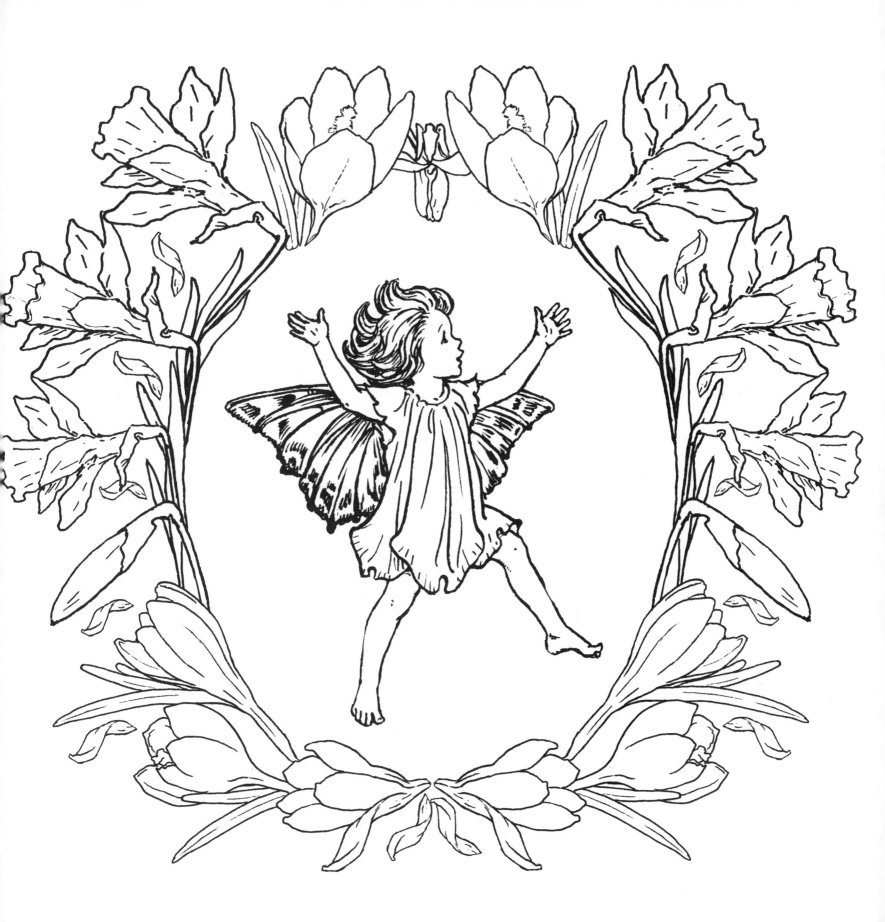

SPRING HAS SPRUNG: DAFFODILS AND CROCUSES

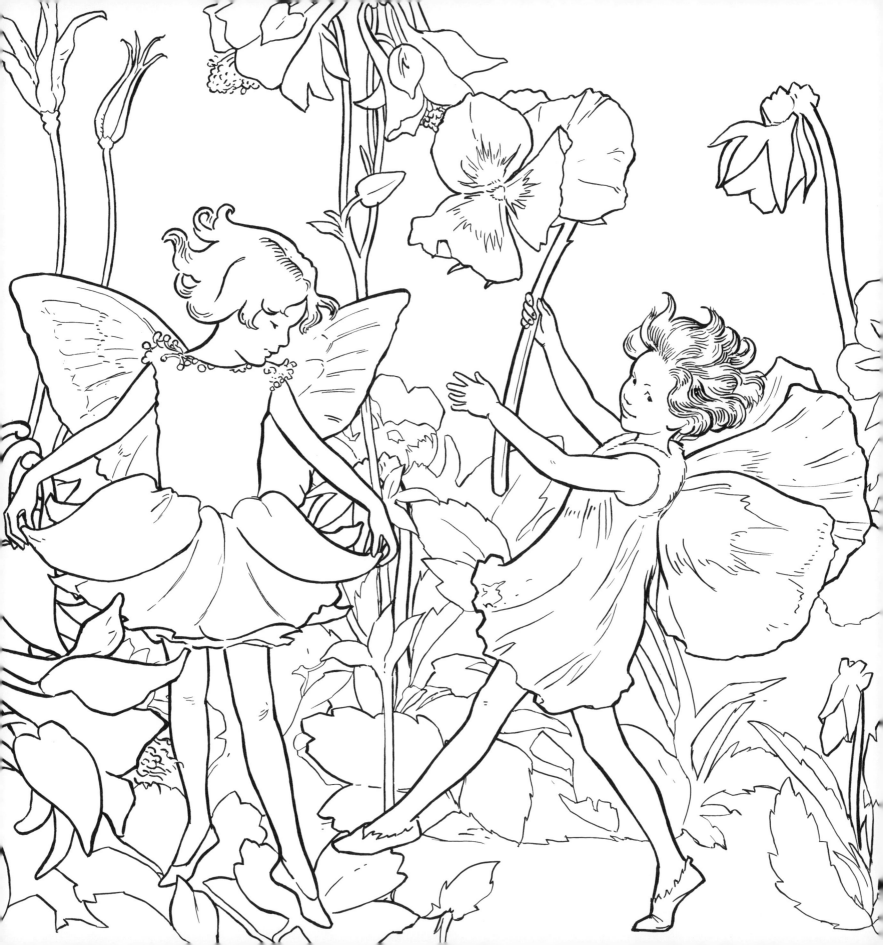

PLAYING AMONG THE PANSIES: THE COLUMBINE AND PANSY FAIRIES

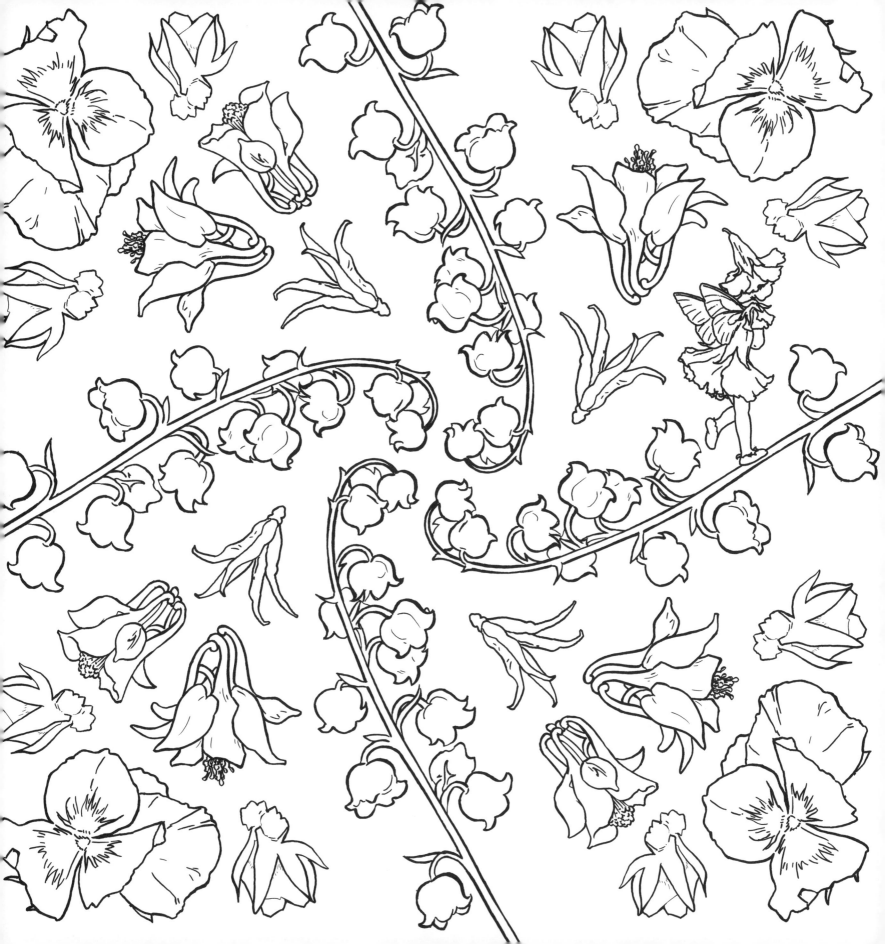

A SPRING SWIRL: LILY-OF-THE-VALLEY, PANSY, AND COLUMBINE FLOWERS

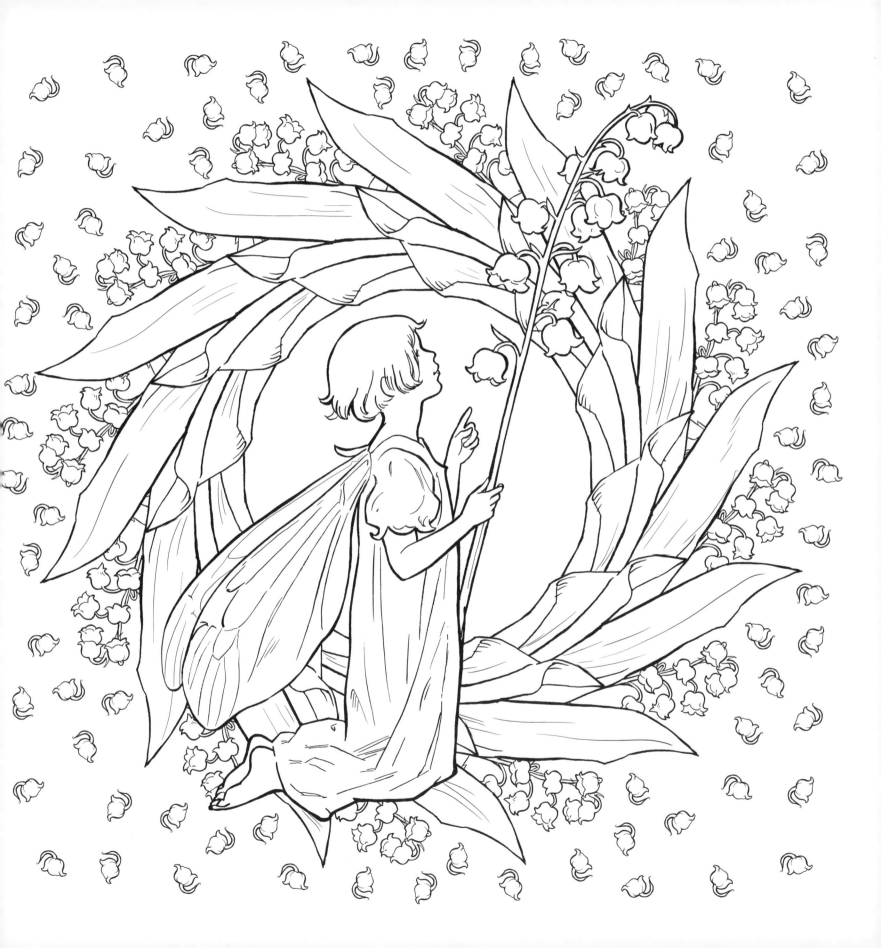

THE LILY-OF-THE-VALLEY FAIRY

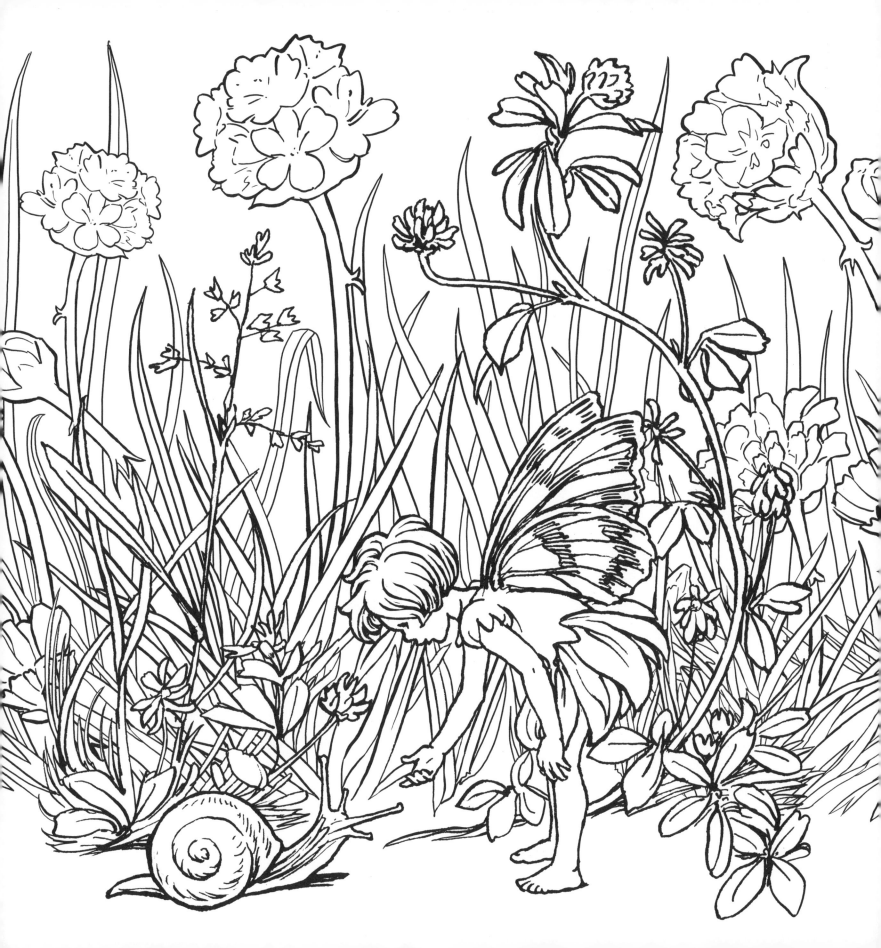

A FRIENDLY ENCOUNTER

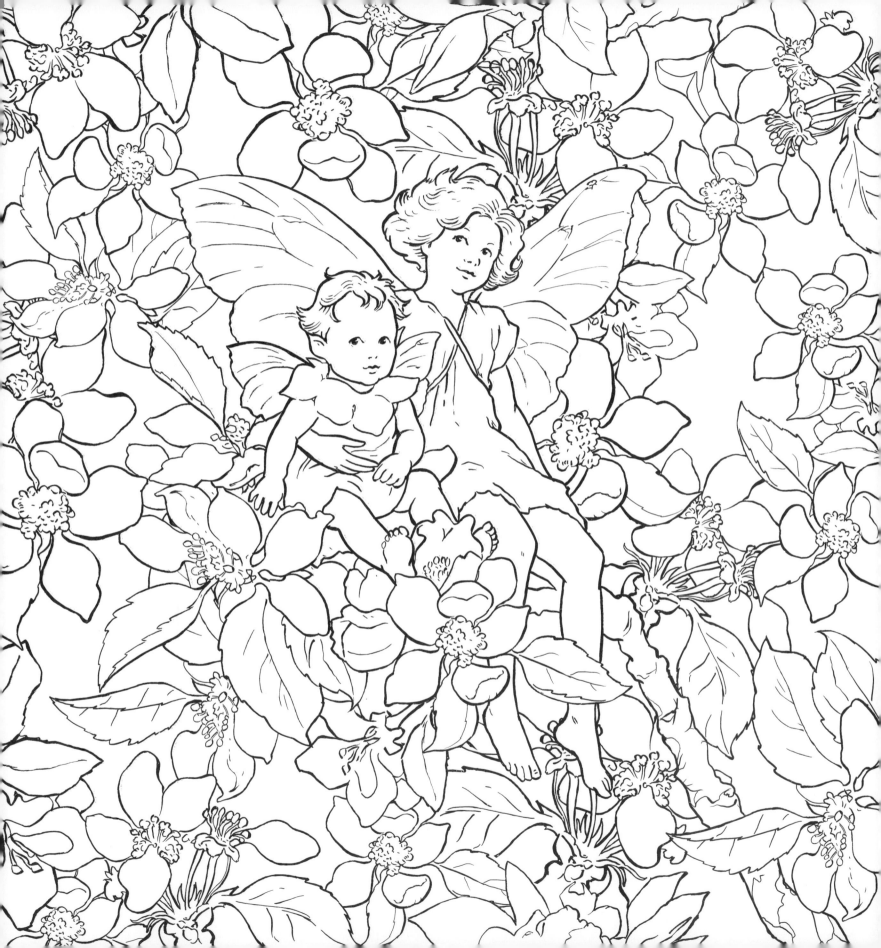

THE APPLE BLOSSOM FAIRIES

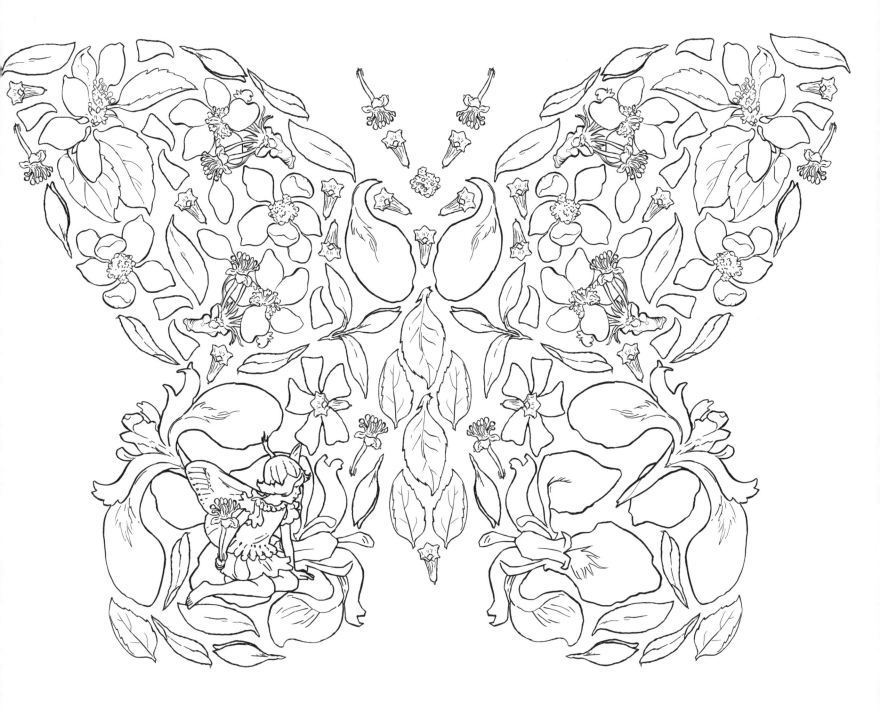

A BLOSSOMING BUTTERFLY: IRIS, APPLE BLOSSOM, AND PERIWINKLE

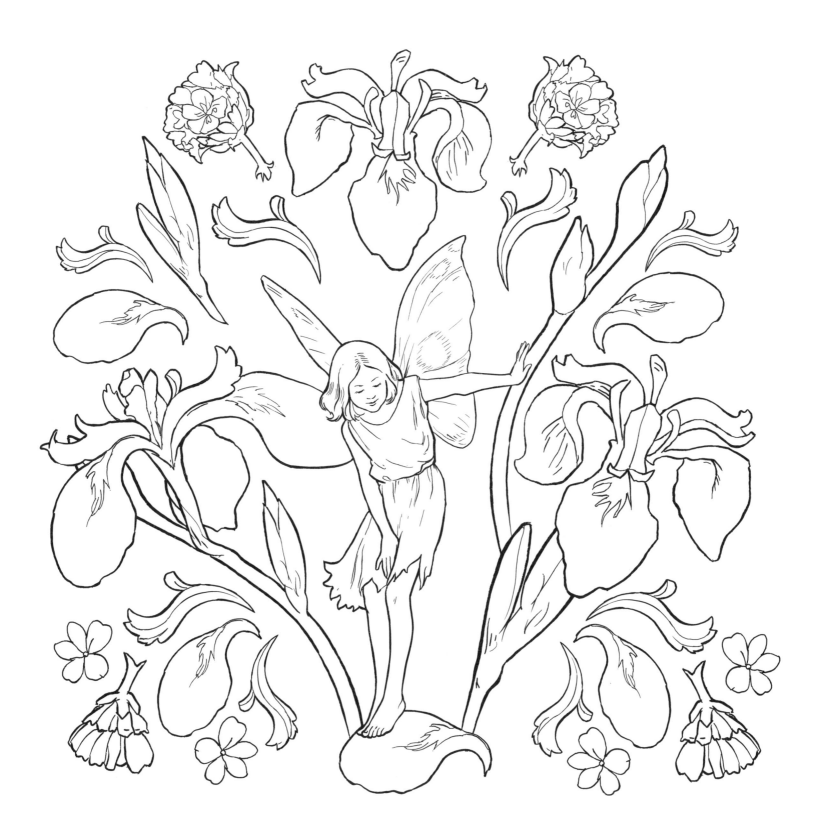

THE INQUISITIVE IRIS FAIRY

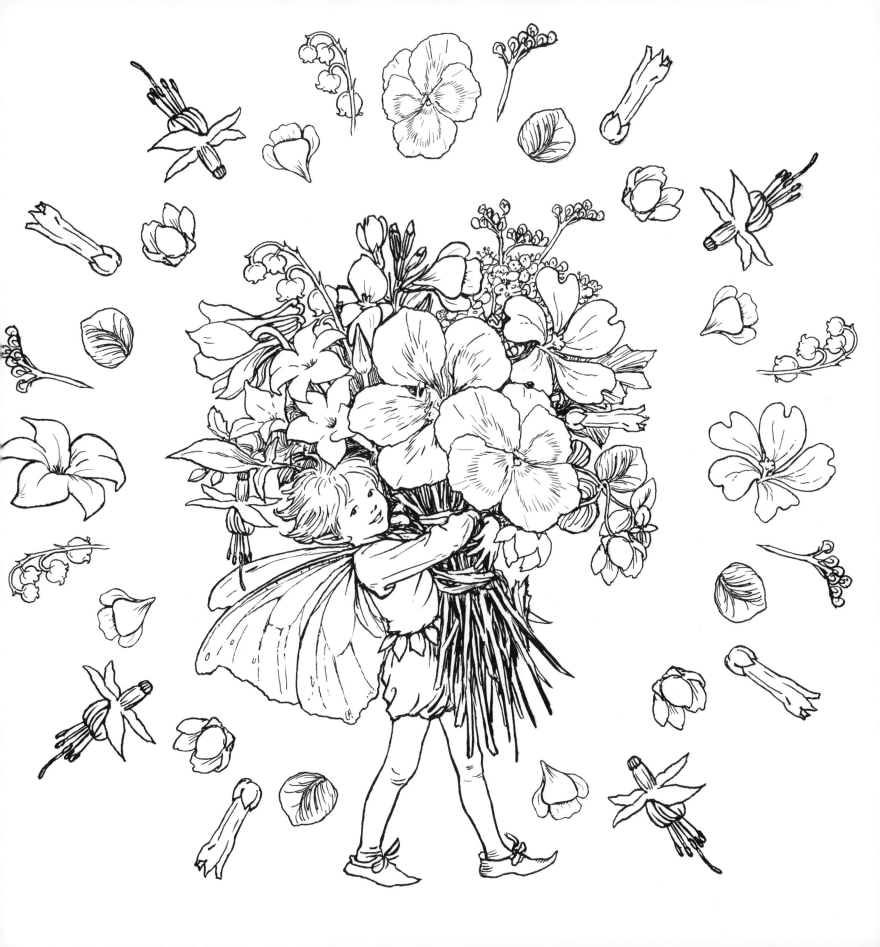

A BURSTING BOUQUET

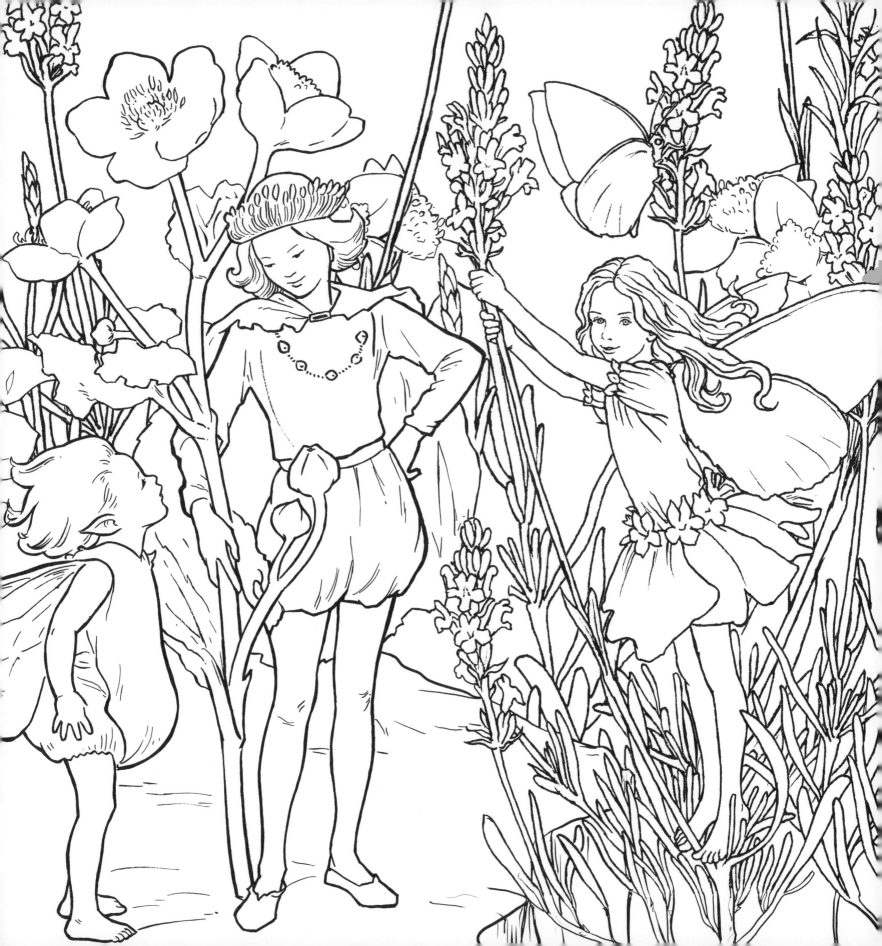

A ROYAL OCCASION: THE KINGCUP AND LAVENDER FAIRIES

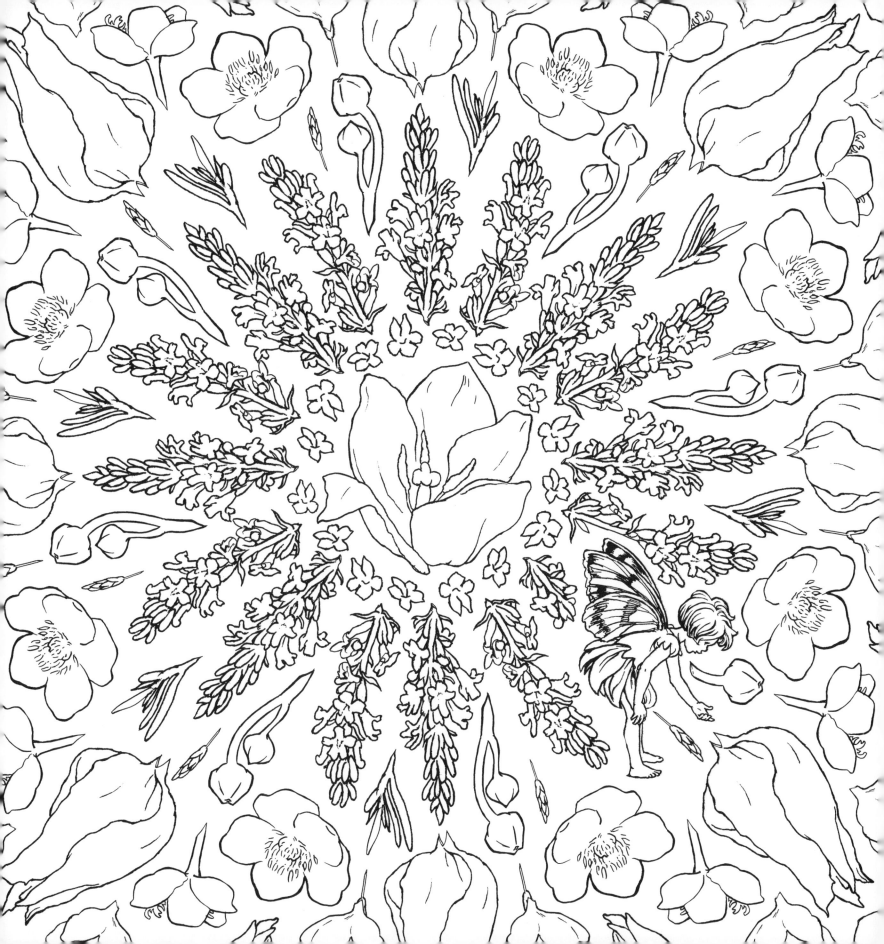

A SPRING SELECTION: LAVENDERS, TULIPS, AND KINGCUP FLOWERS

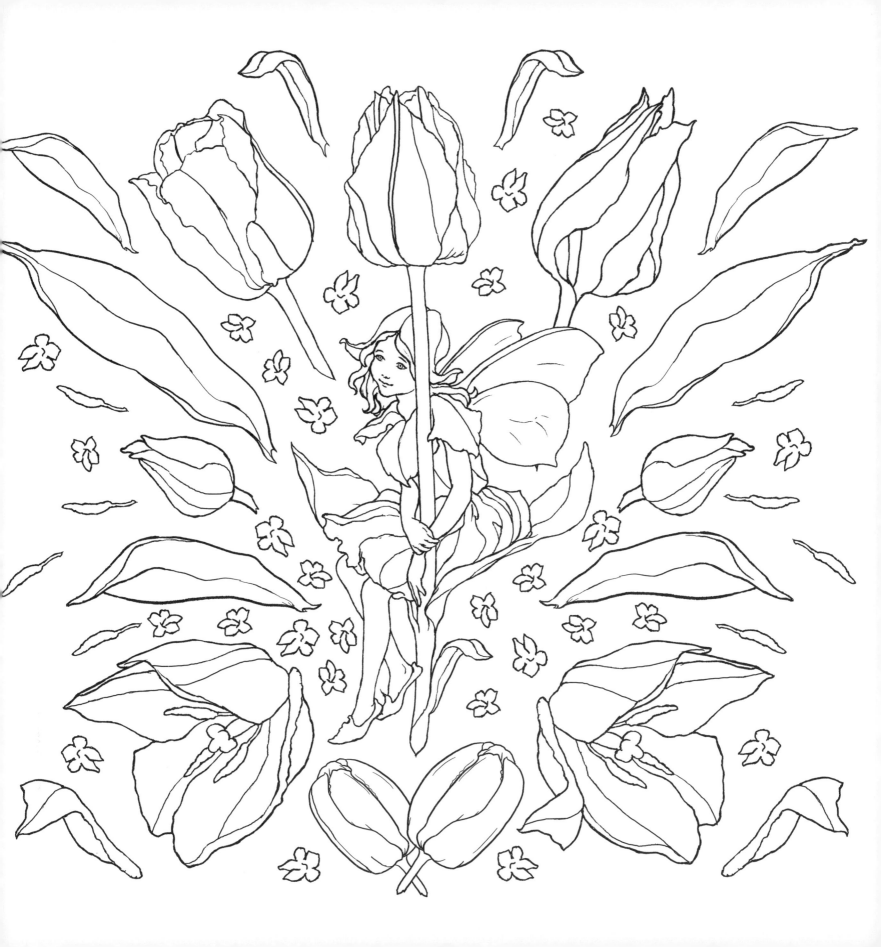

THE TULIP FAIRY DEEP IN THOUGHT

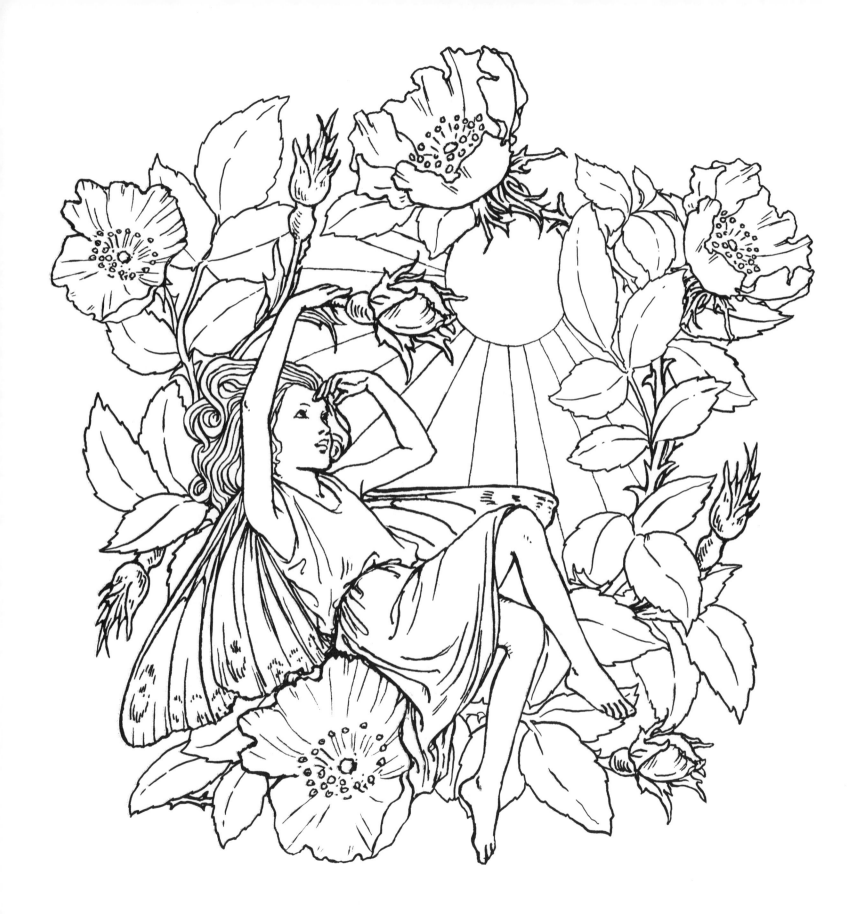

BASKING IN THE SUMMER SUNSHINE

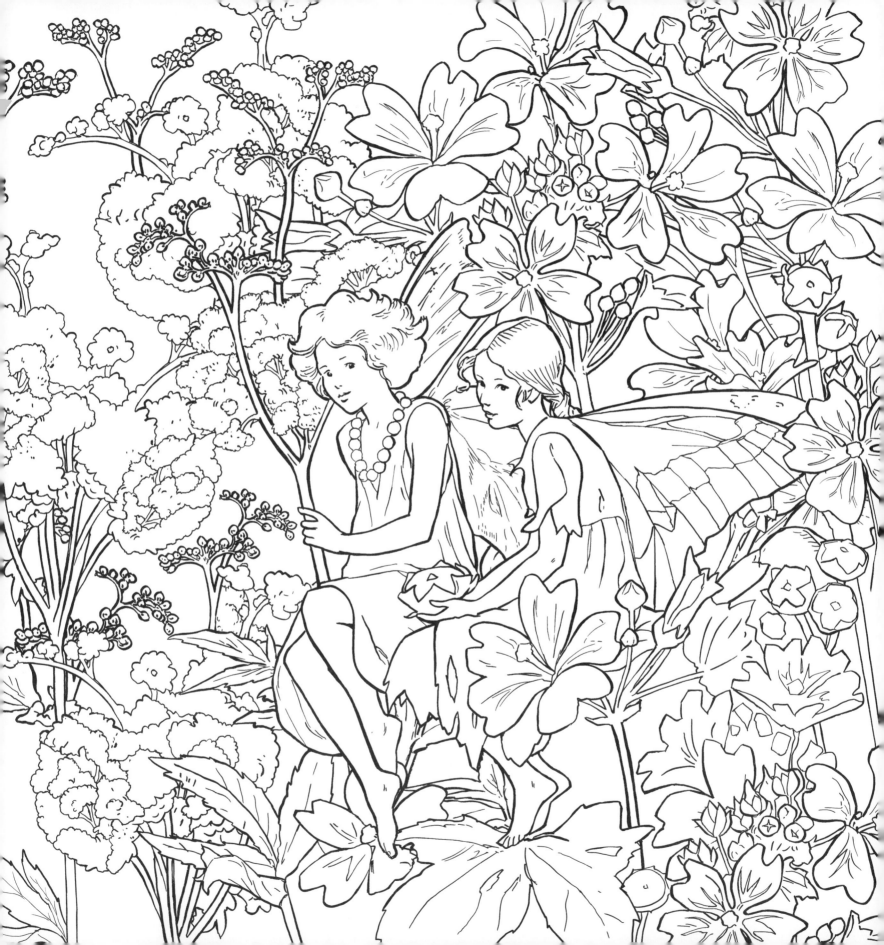

A QUEEN'S COMPANY: THE QUEEN OF THE MEADOW AND MALLOW FAIRIES

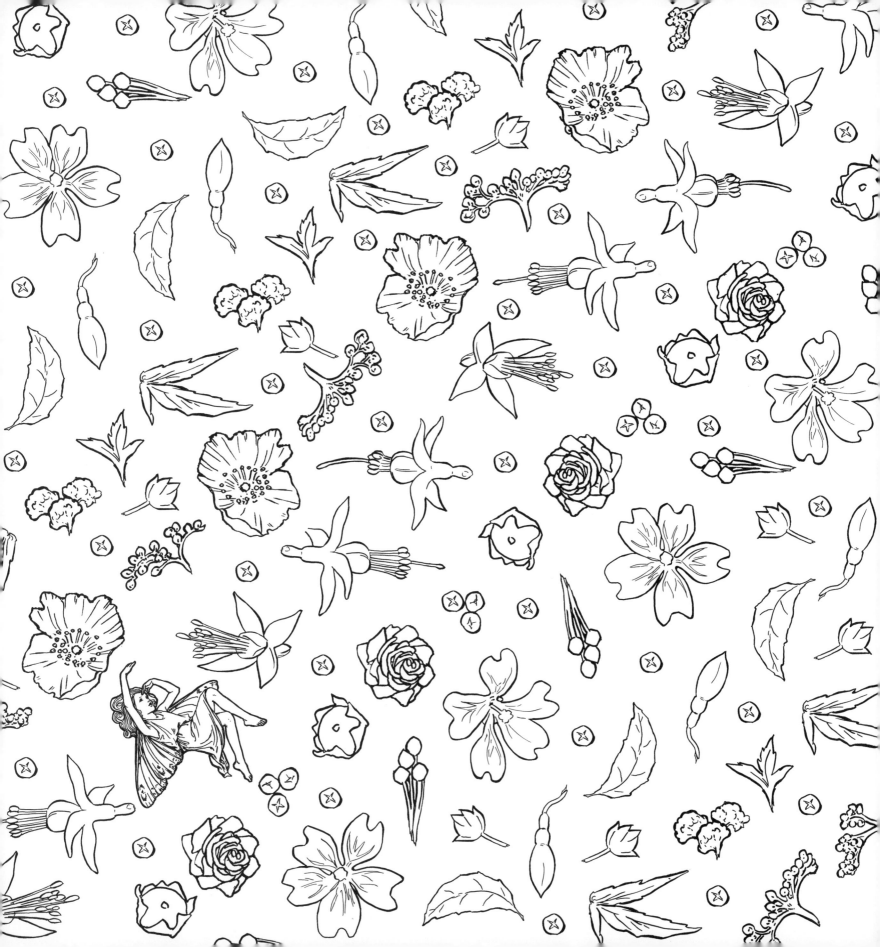

FUCHSIA, MALLOW, AND QUEEN OF THE MEADOW FLOWERS

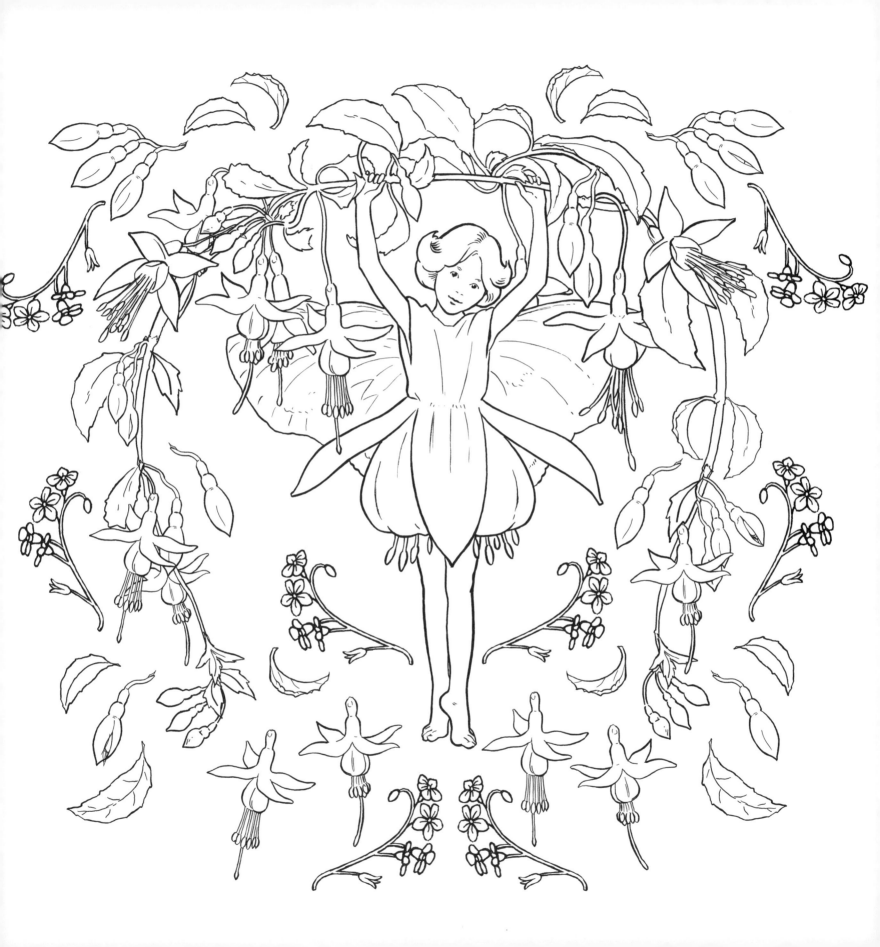

THE FUCHSIA FAIRY

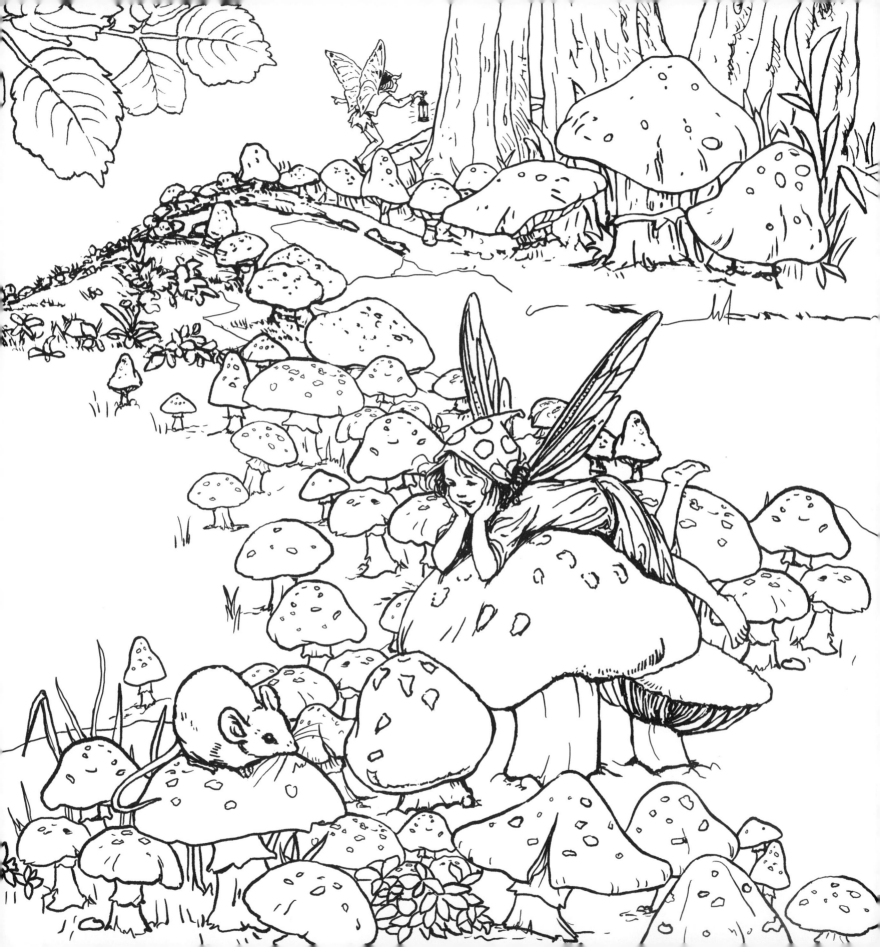

OBSERVING FROM UPON A TOADSTOOL

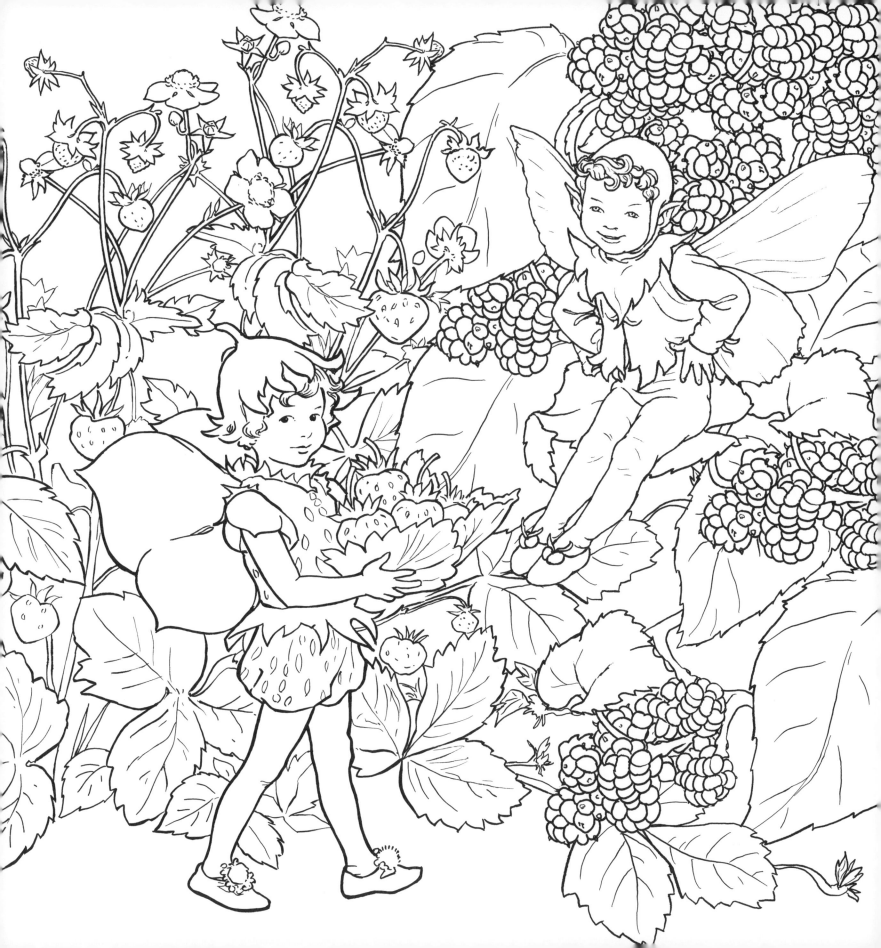

AN ABUNDANCE OF BERRIES: THE STRAWBERRY AND MULBERRY FAIRIES

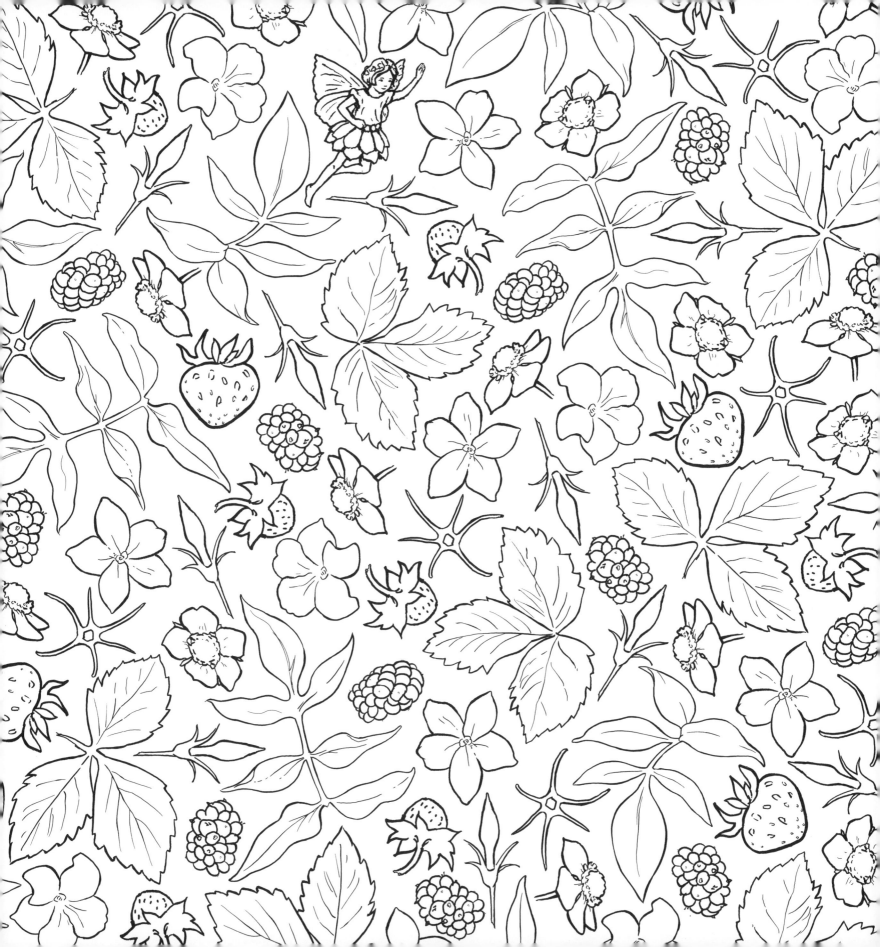

STRAWBERRY, MULBERRY, AND JASMINE FLOWERS

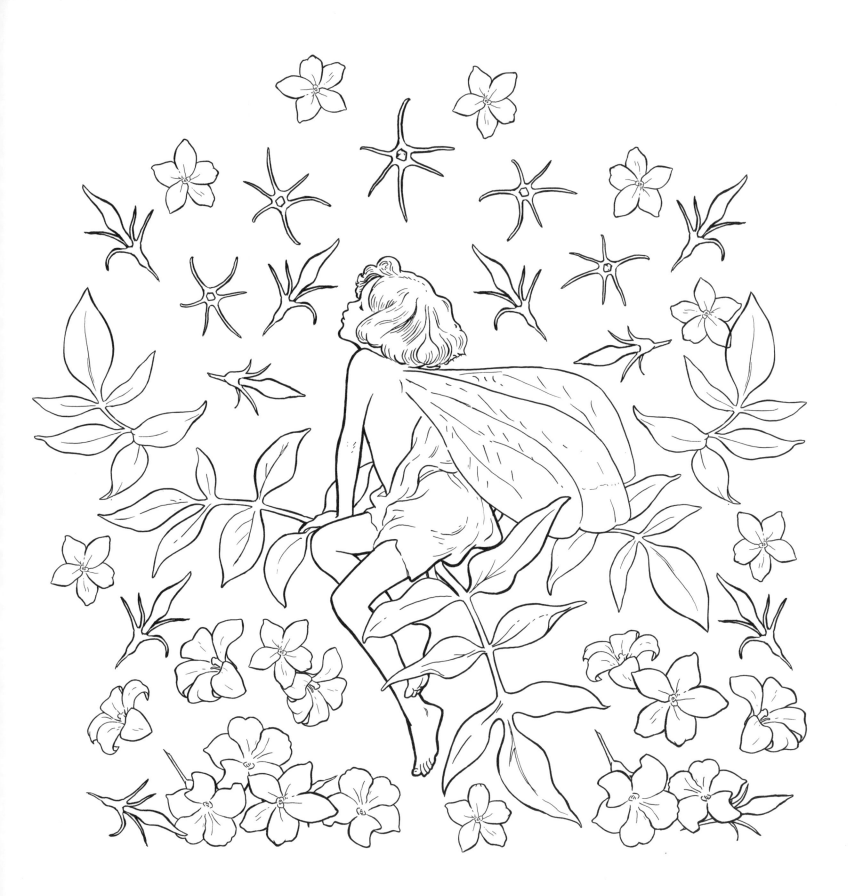

THE JASMINE FAIRY

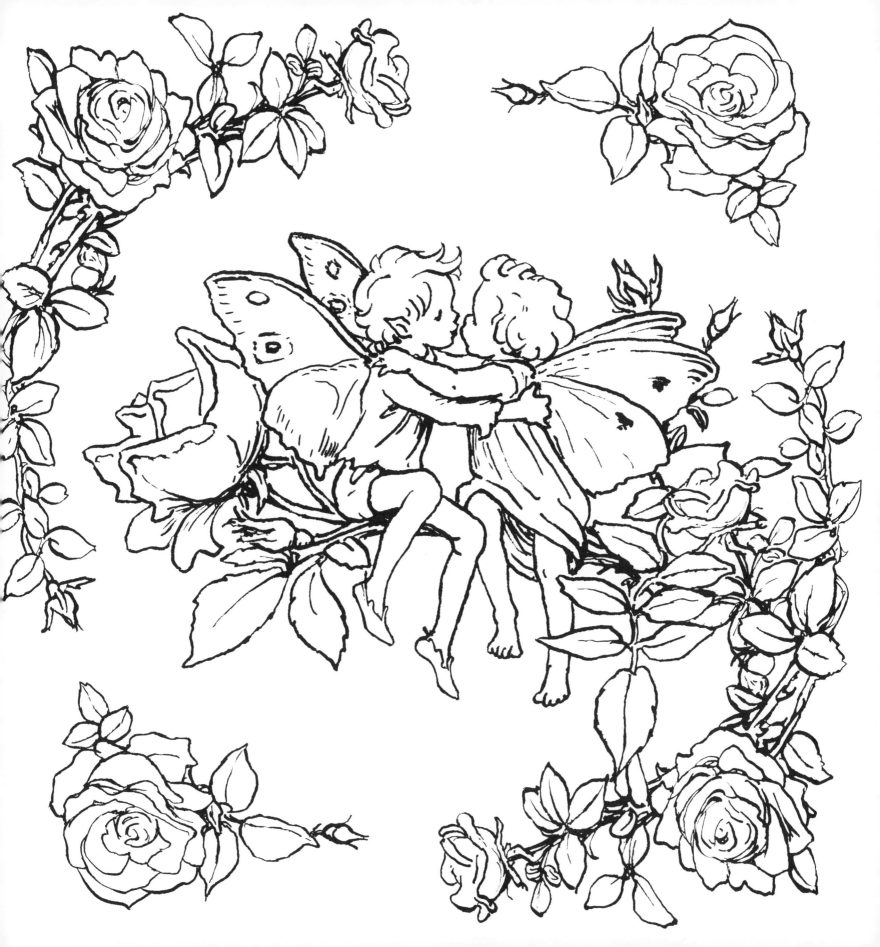

A ROSE FOR MY VALENTINE

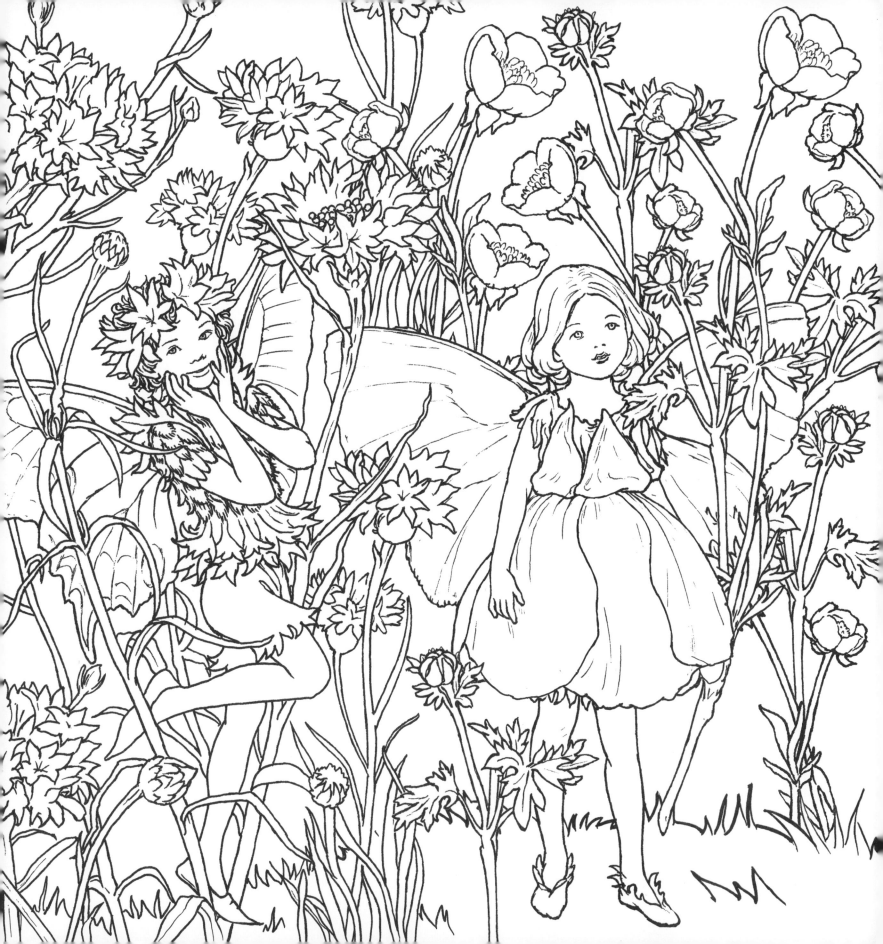

A BLOSSOMING FRIENDSHIP: CORNFLOWER AND BUTTERCUP FAIRIES

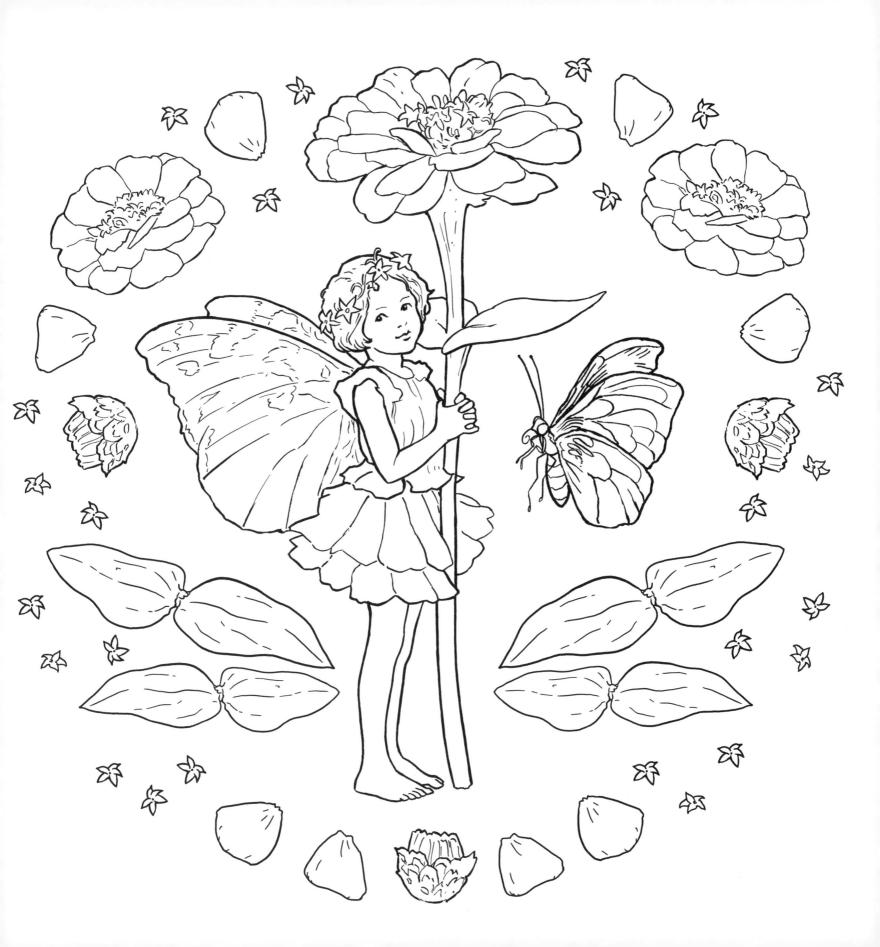

THE ZINNIA FAIRY

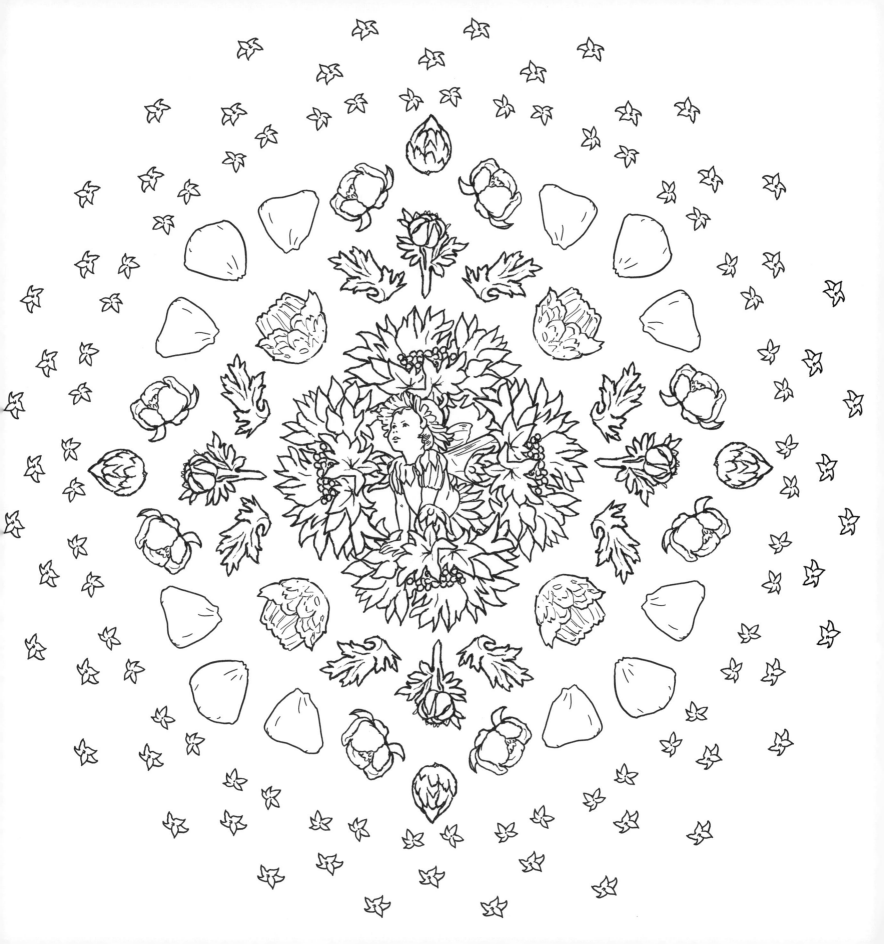

CORNFLOWER, BUTTERCUP, AND ZINNIA FLOWERS

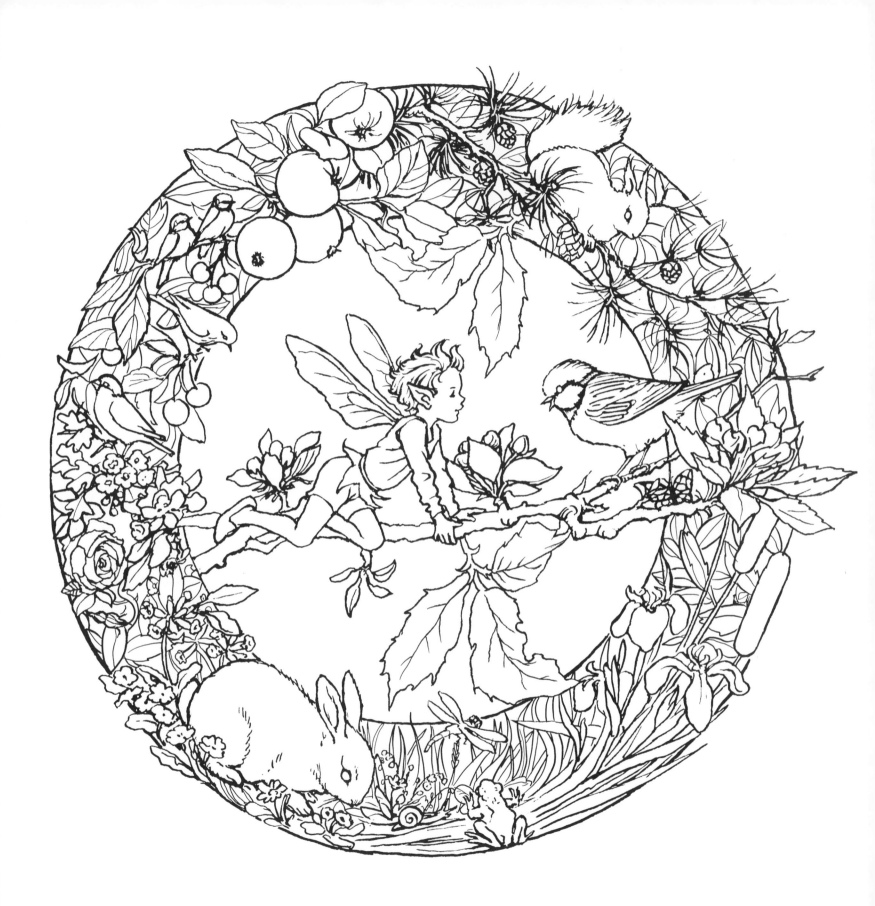

BALANCING UPON A BRANCH

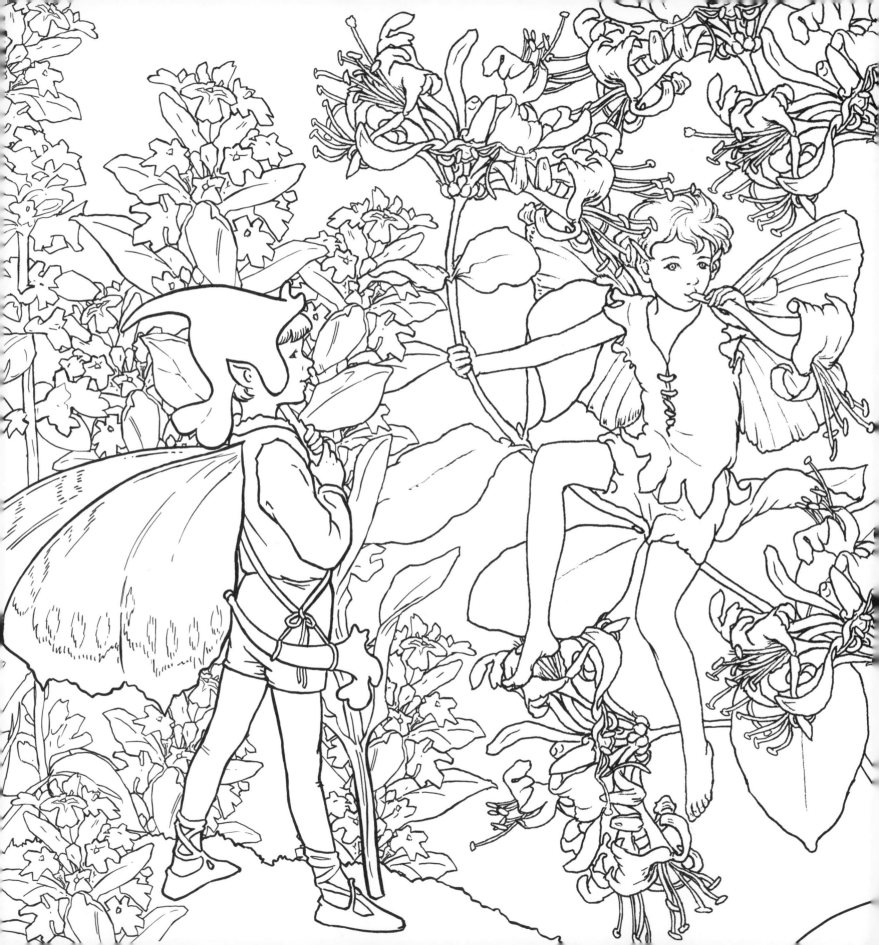

MAGICAL MELODIES: THE BUGLE AND HONEYSUCKLE FAIRIES

BUGLE, HONEYSUCKLE, AND DOUBLE DAISY FLOWERS

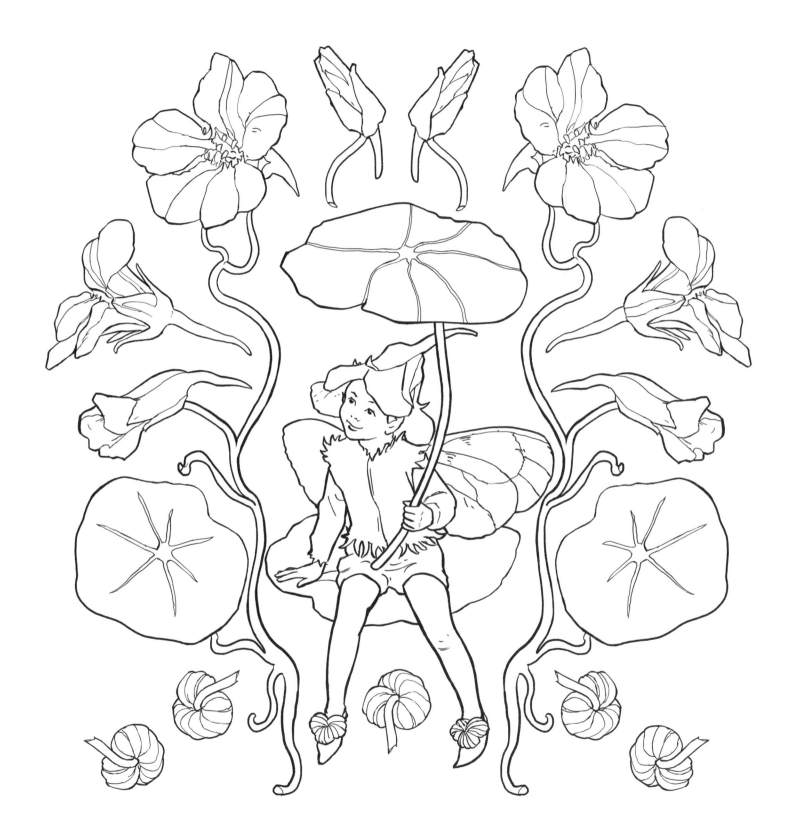

SHELTERING IN THE SHADE: THE NASTURTIUM FAIRY

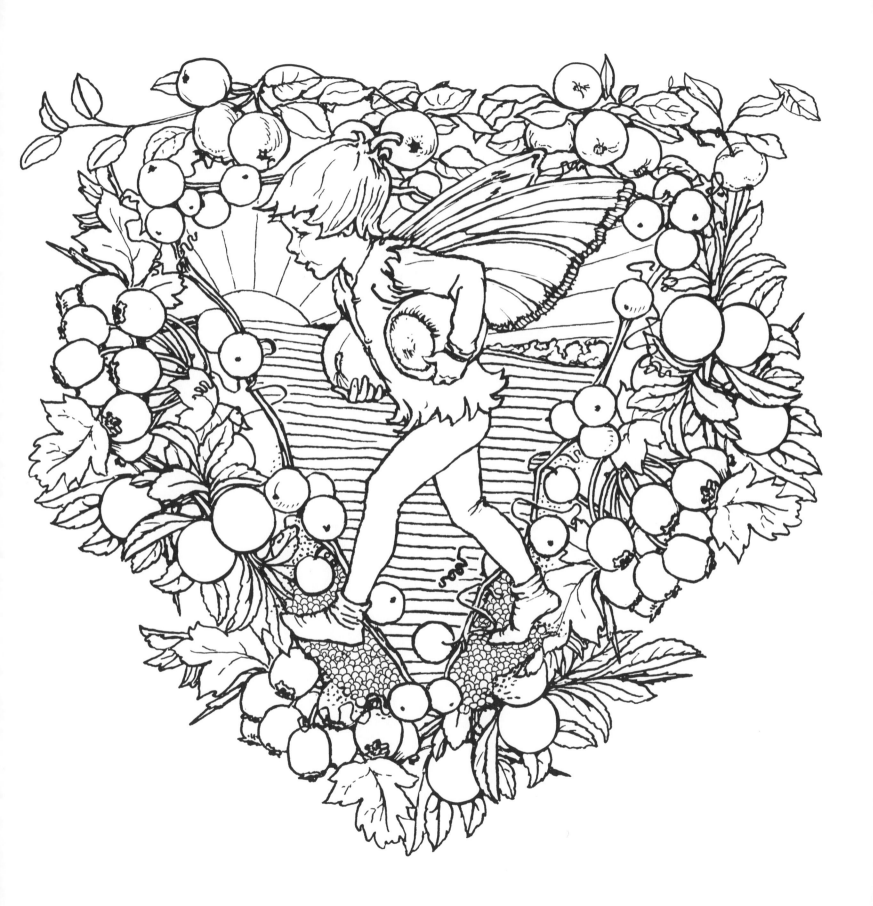

A HAZELNUT UNDER EACH ARM

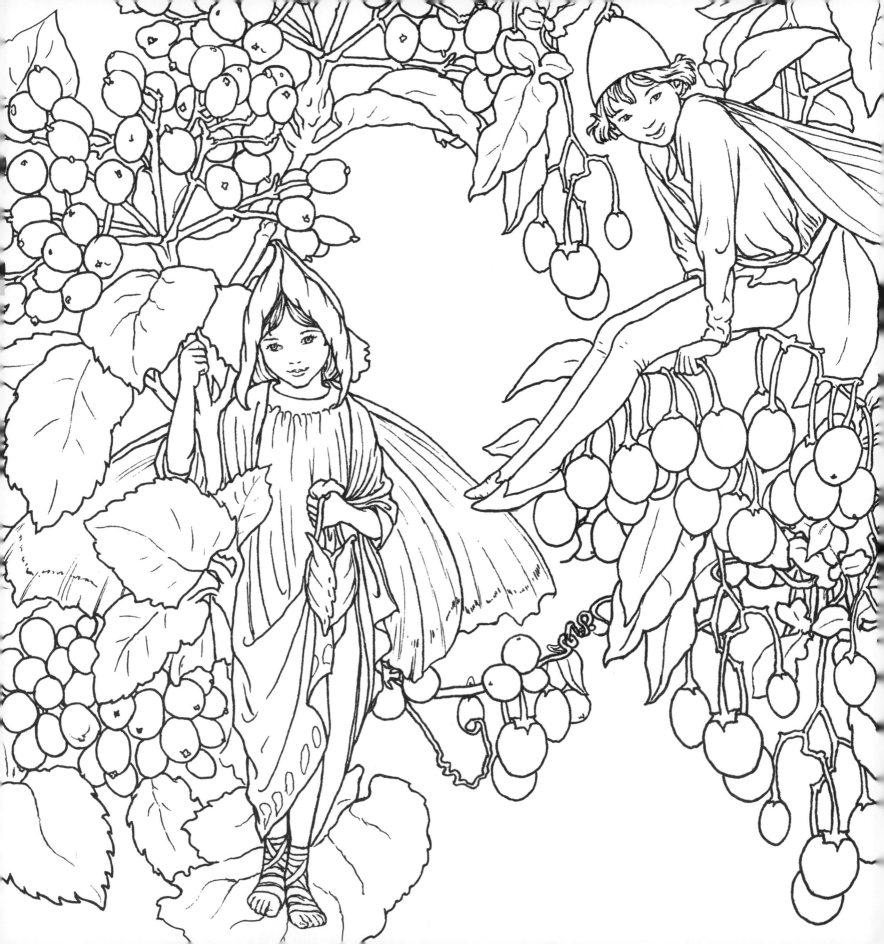

THE WAYFARING TREE AND NIGHTSHADE BERRY FAIRIES

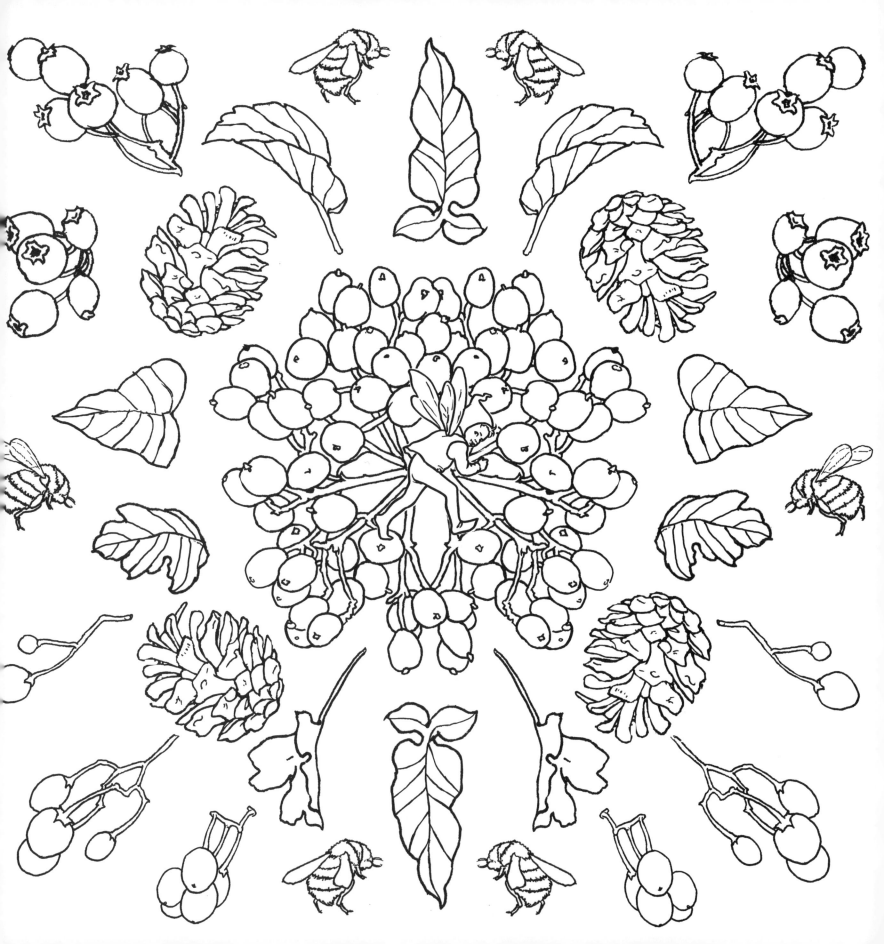

WAYFARING TREE, NIGHTSHADE BERRY, AND HAWTHORN FLOWERS AND LEAVES

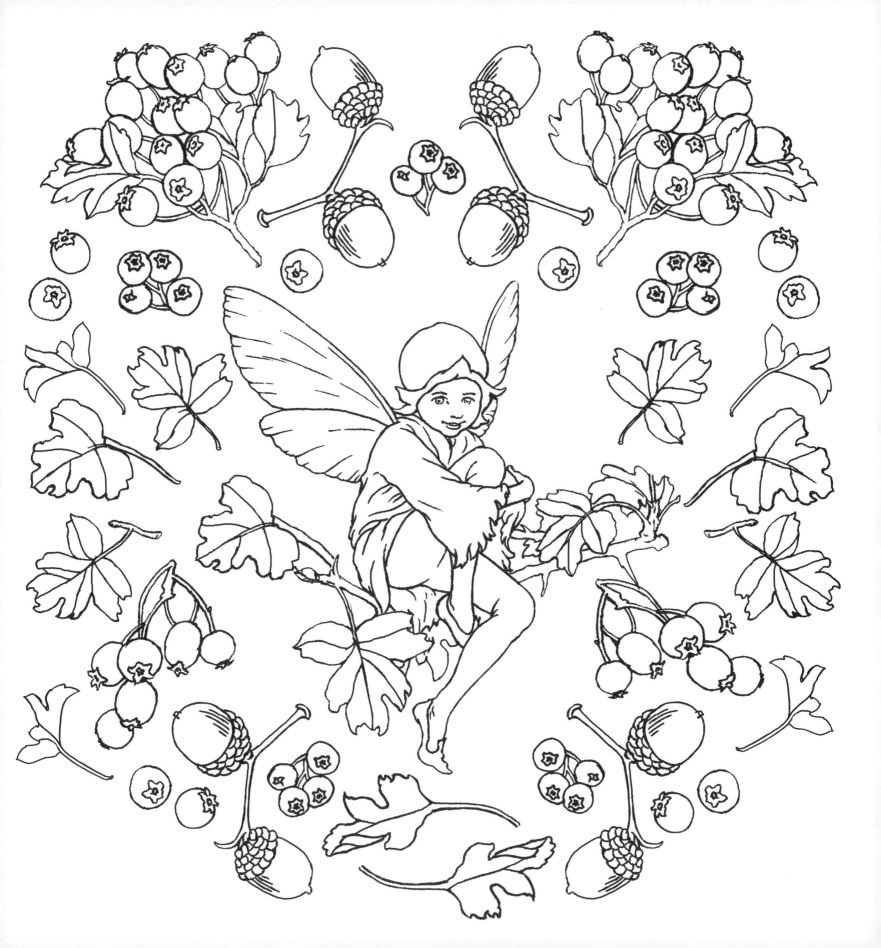

THE HAWTHORN FAIRY

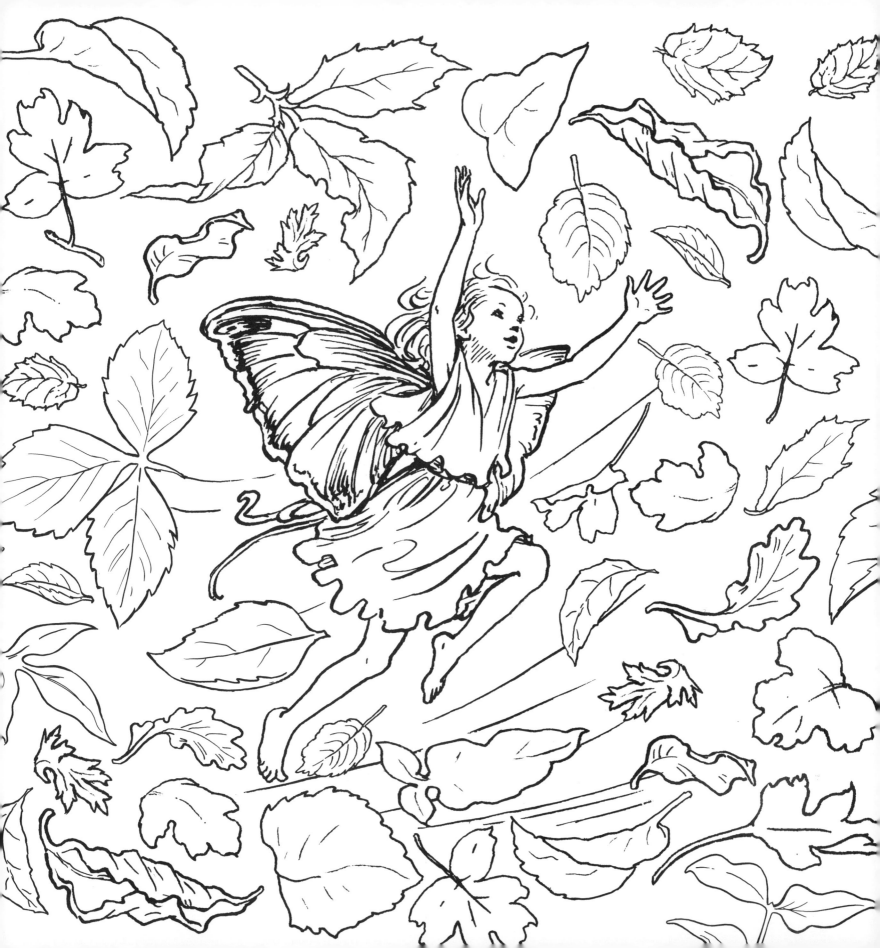

FALLING LEAVES

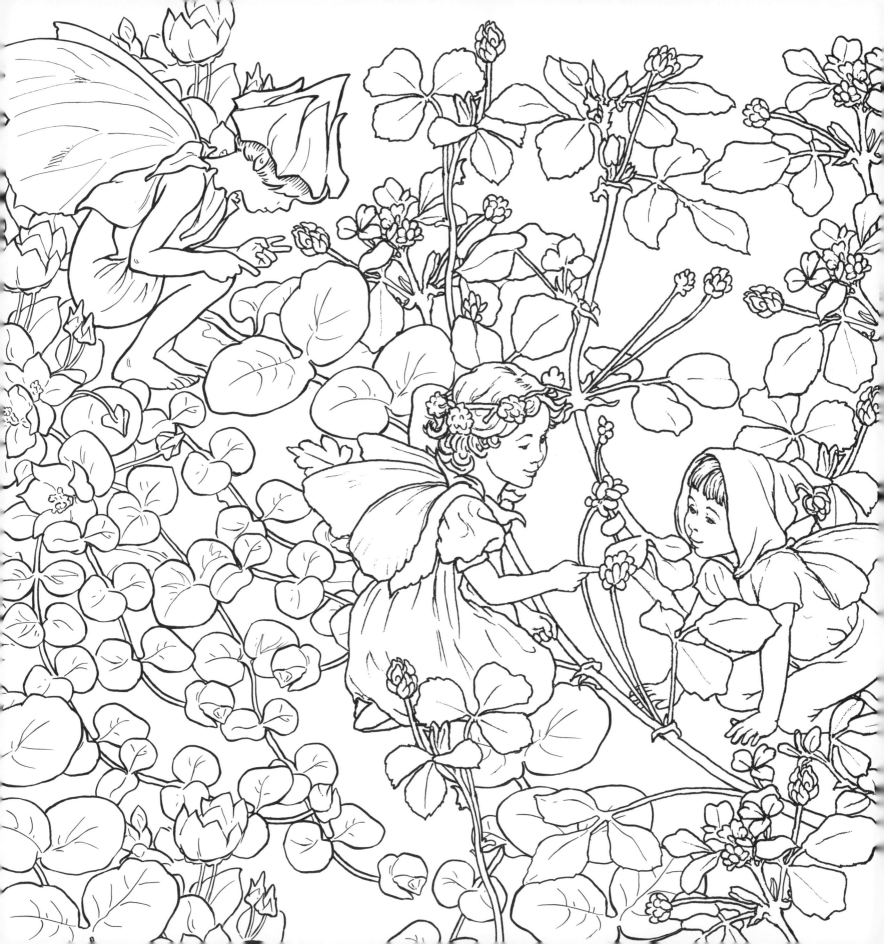

A SUBLIME SCENT: THE HERB TWOPENCE AND BLACK MEDICK FAIRIES

TANSY, HERB TWOPENCE, AND BLACK MEDICK FLOWERS AND LEAVES

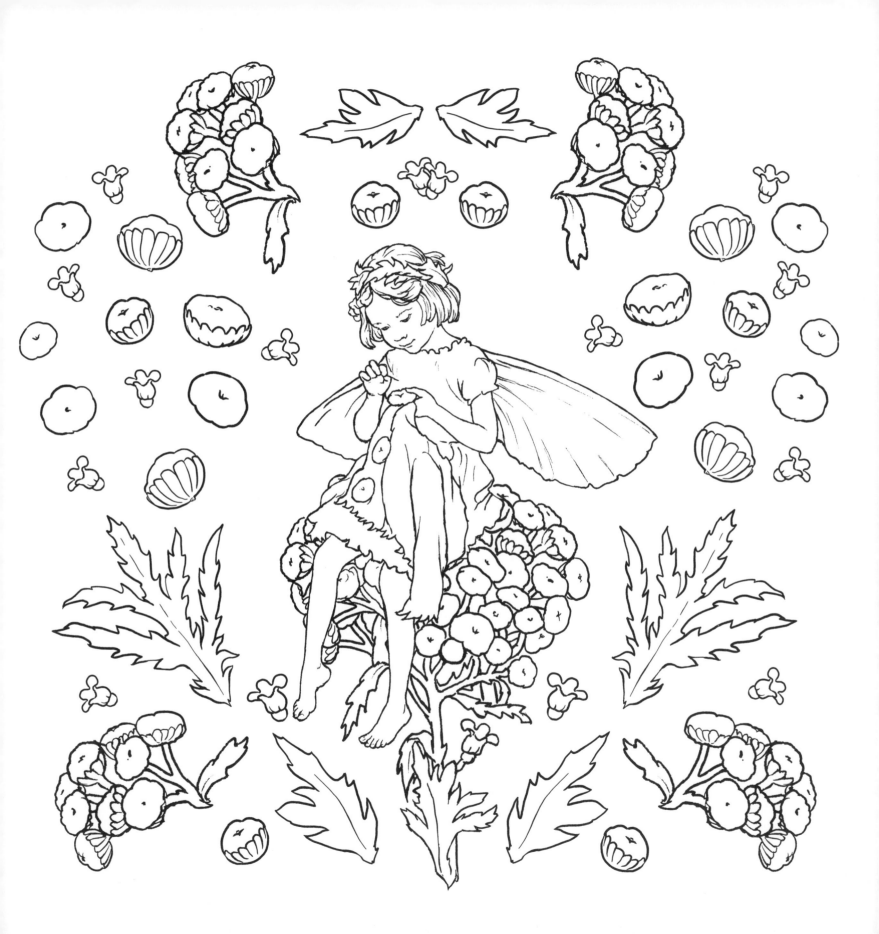

THE TANSY FAIRY

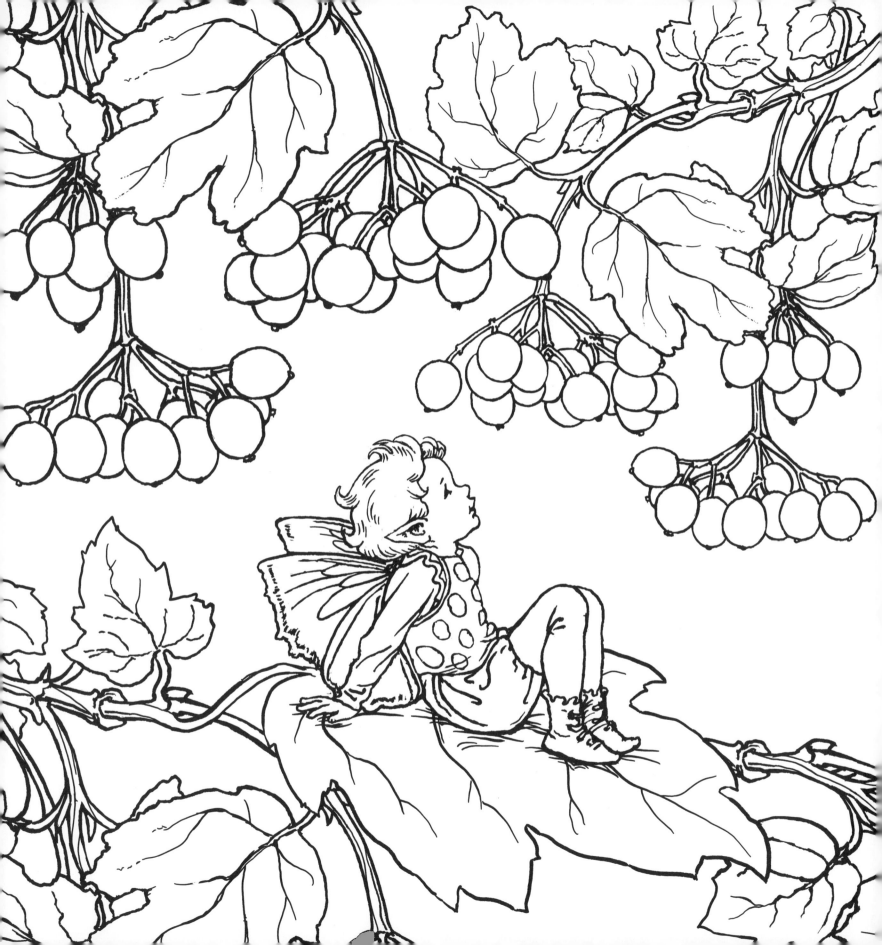

HANGING BERRIES

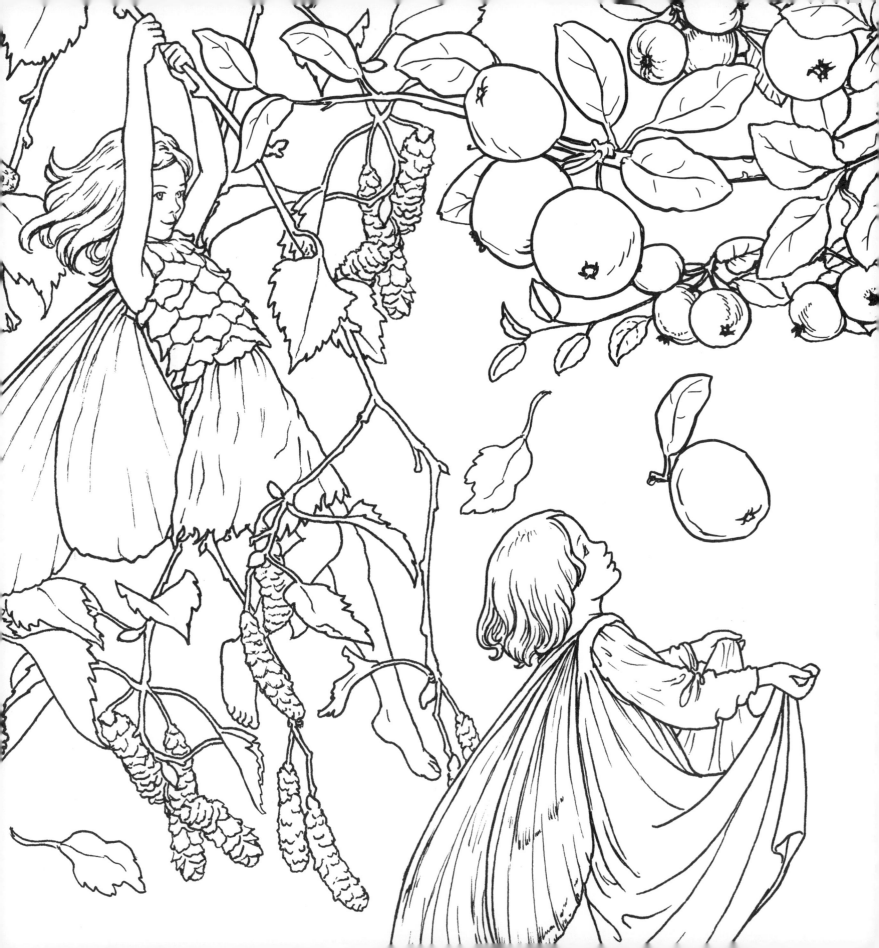

GATHERING CRAB-APPLES: THE SILVER BIRCH AND CRAB-APPLE FAIRIES

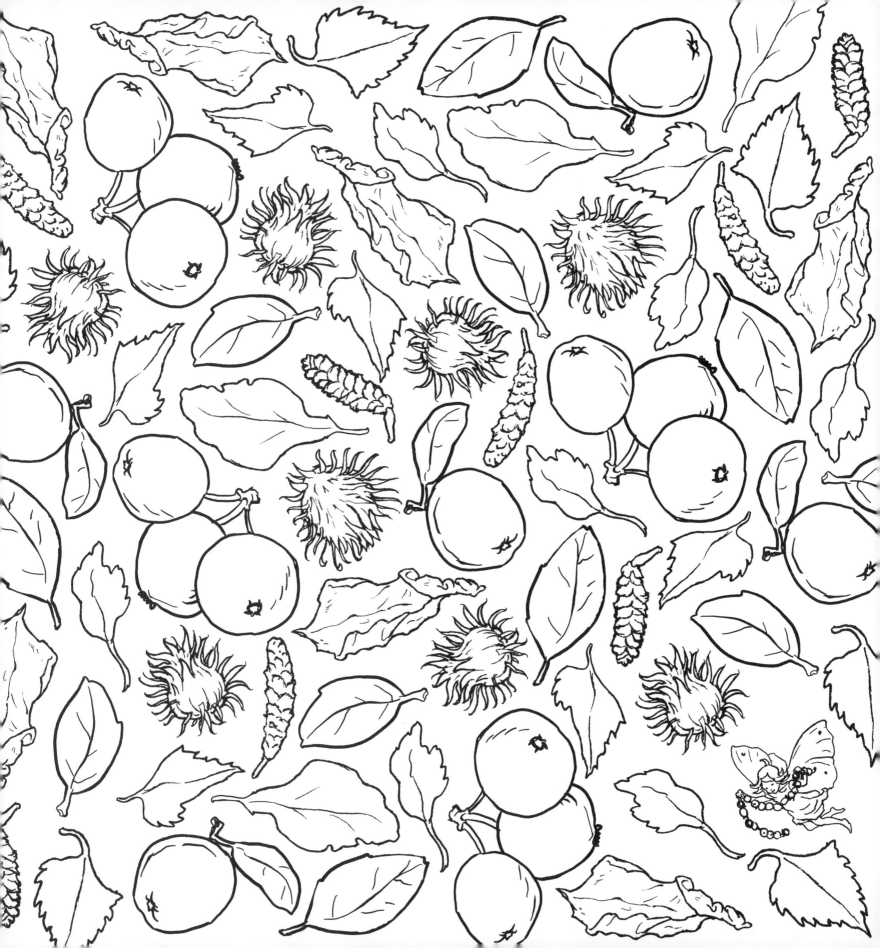

CRAB-APPLES, BURDOCK, AND SILVER BIRCH

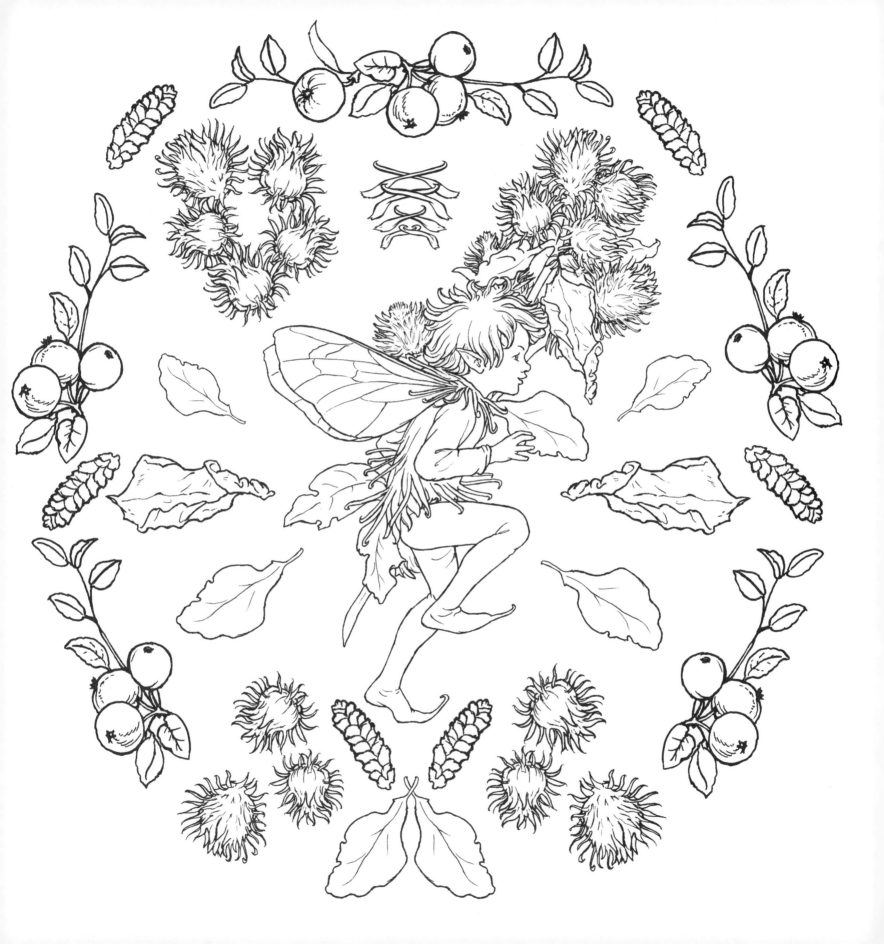

THE BURDOCK FAIRY

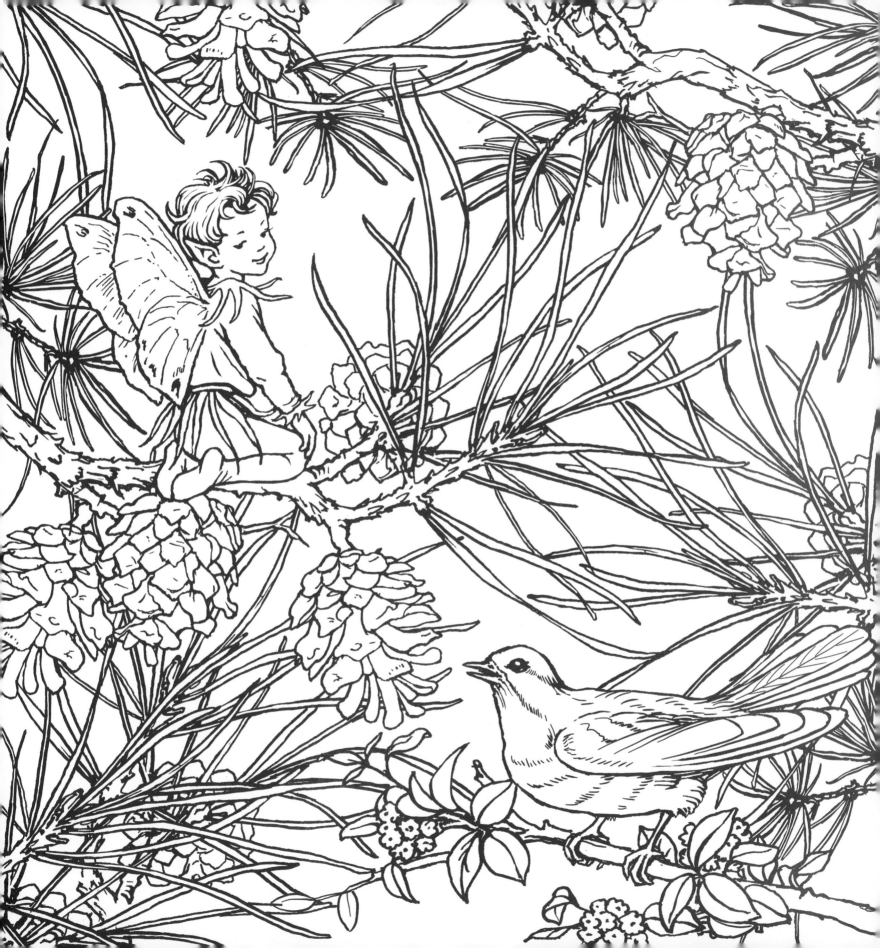

SWEET BIRDSONG

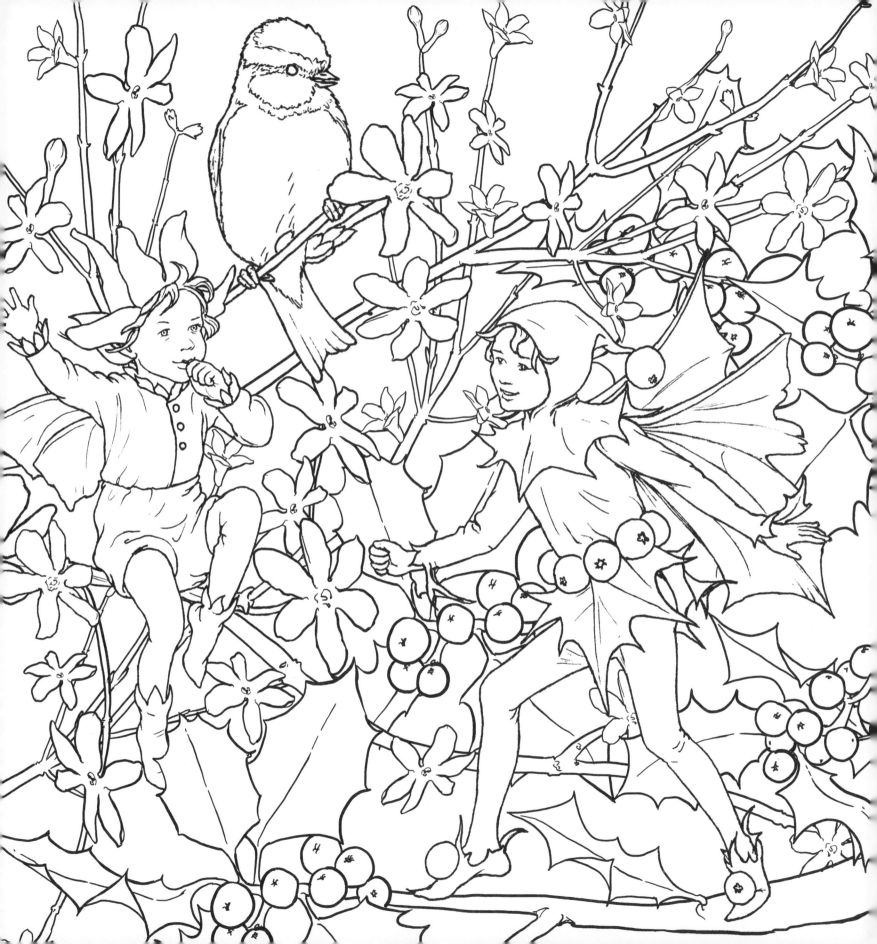

WINTER FRIENDS: THE WINTER JASMINE AND HOLLY FAIRIES

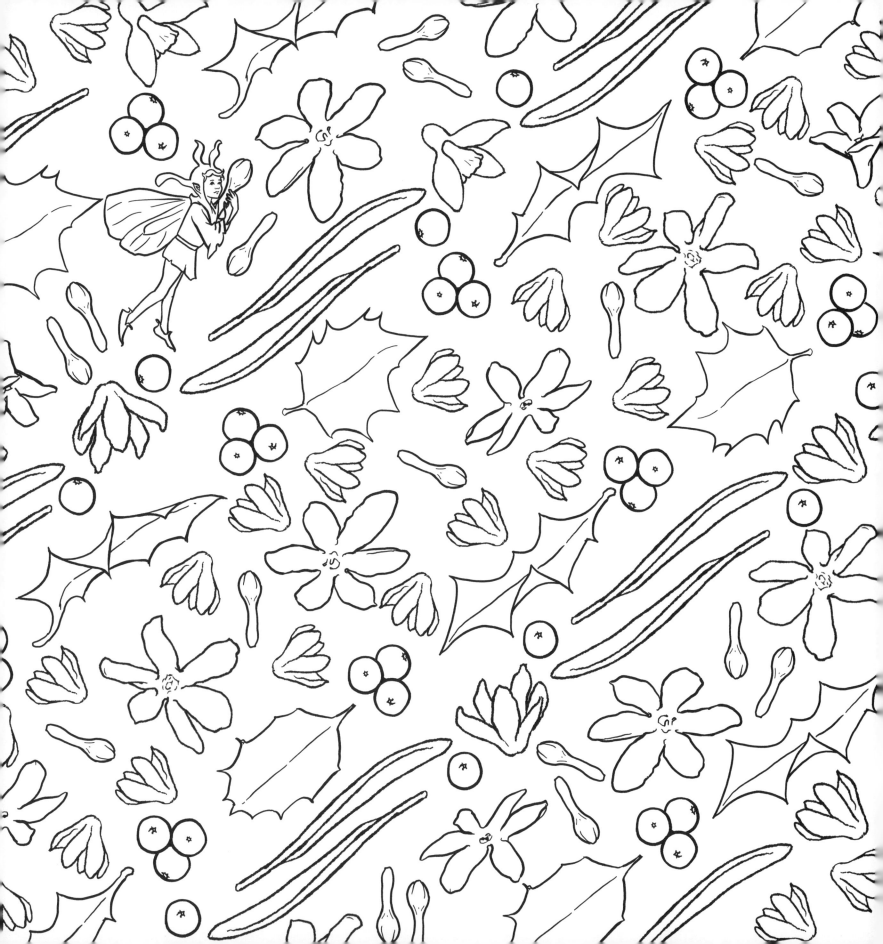

SNOWDROPS, HOLLY, AND WINTER JASMINE

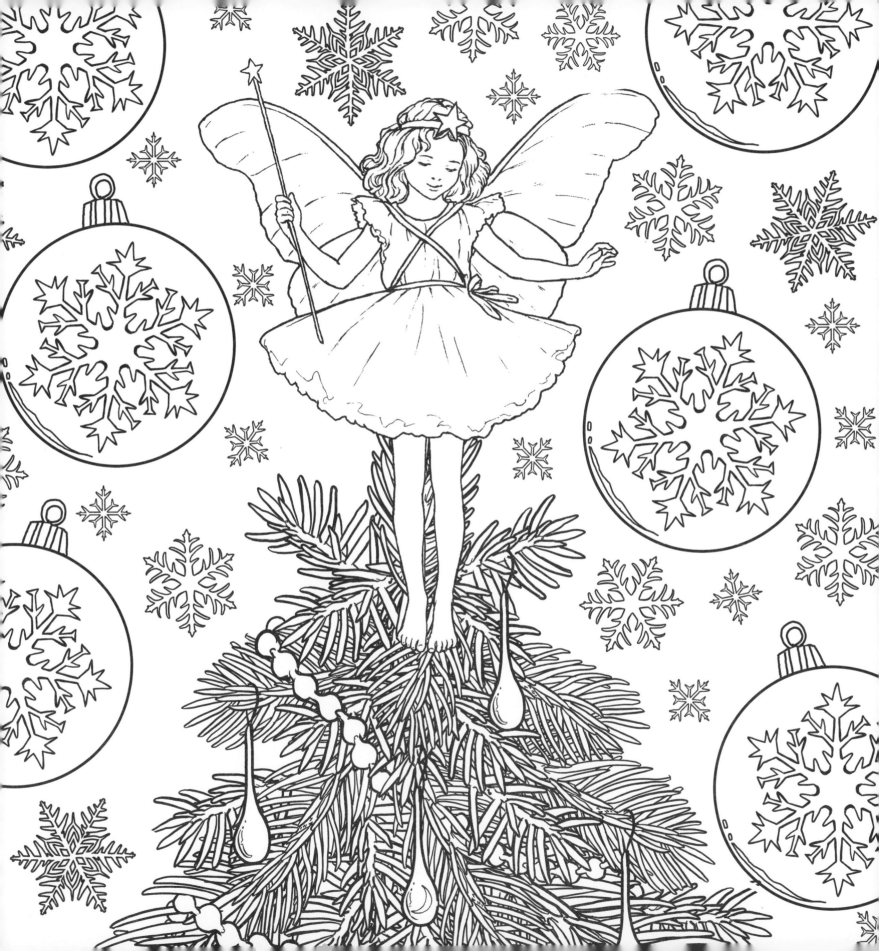

A MOST MAGICAL CHRISTMAS: THE CHRISTMAS TREE FAIRY

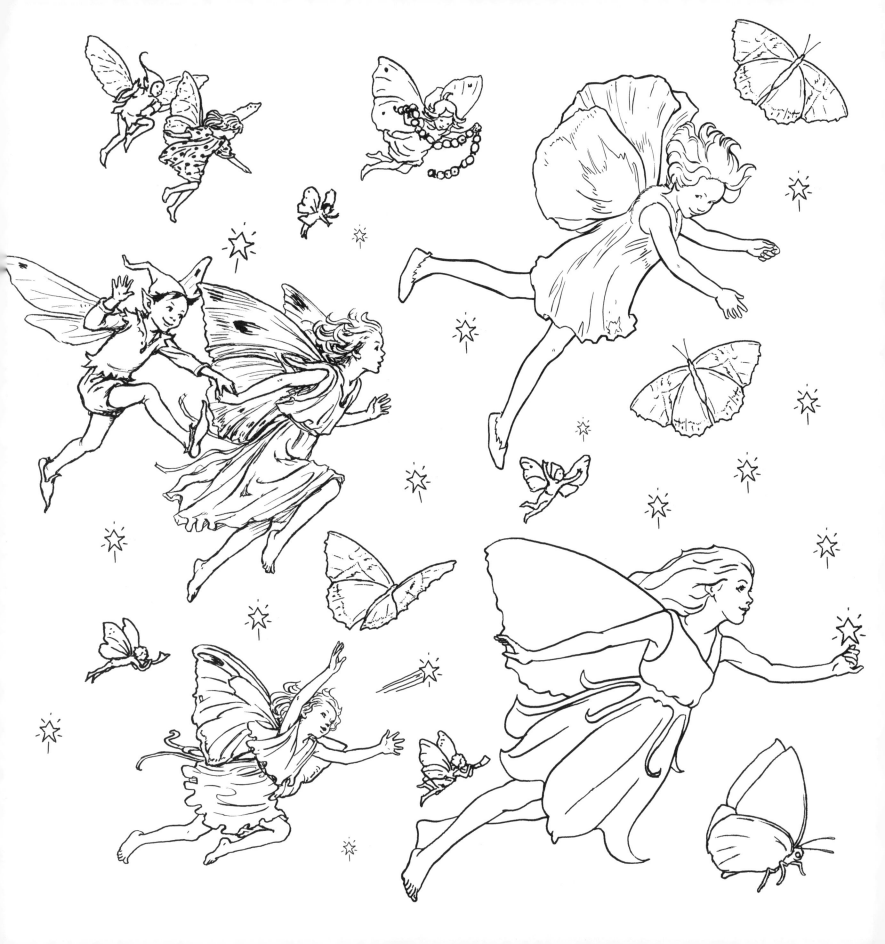

IN FLIGHT ON A STARRY NIGHT